Art Classics

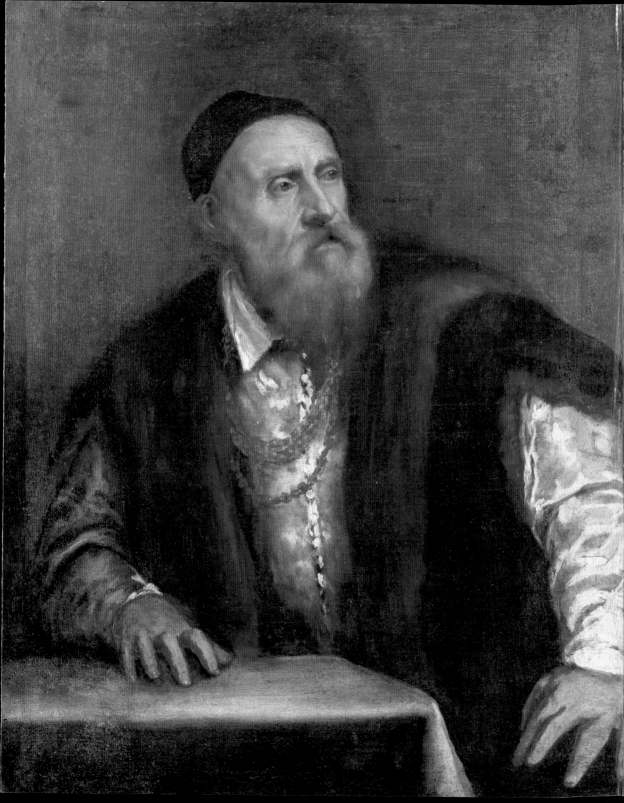

Art Classics

TITIAN

Preface by Corrado Cagli

RIZZOLI
NEW YORK

ART CLASSICS

TITIAN

First published in the United States
of America in 2006 by
Rizzoli International Publications, Inc.
300 Park Avenue South
New York, NY 10010
www.rizzoliusa.com

Originally published in Italian by
Rizzoli Libri Illustrati
© 2004 RCS Libri Spa, Milano
All rights reserved
www.rcslibri.it
First edition 2003
Rizzoli \ Skira – Corriere della Sera

2005 2006 2007 2008 2009 /
10 9 8 7 6 5 4 3 2 1

Printed in China

ISBN: 0-8478-2811-5

Library of Congress Control
Number: 2005933787

Director of the series
Eileen Romano

Design
Marcello Francone

Translation
Timothy Stroud
(Buysschaert&Malerba)

Editing and layout
Buysschaert&Malerba, Milan

cover
Bacchus and Ariadne
(detail), 1522–1523,
London, National
Gallery

frontispiece
Self-portrait
(detail), *c.* 1562
Berlin, Staatliche Museen
zu Berlin, Preußischer Kulturbesitz,
Gemäldegalerie

The publication of works owned by
the Soprintendenze has been made
possible by the Ministry for Cultural
Goods and Activities.

© Archivio Scala, Firenze

Contents

The Space of Time
by *Corrado Cagli*

Titian has varied over time our viewpoint on his work and his extraordinary achievements: our viewpoint is the period of the first century that we are living. The place: a sliver of a century that has been torn to shreds like no other in history; shredded to the point of finding lacerated once again the connective tissues of those individuals who, born in the fifth century before Christ, had enforced a flow (not torrential but constant) on the history of man up until yesterday.

Whereas the fifth century was filled with seminal spirits (Confucius, Buddha, Plato, Pythagoras) and saw Lao-Tzû plant the seed of the Tâo with the Tâo-tê-king, our century, the twentieth after Christ, saw the end of Taoism, indeed its oblivion, during its first few decades.

History places our viewpoint of Titian in a point in time riven by deep chasms and illuminated by the sunset of pre-existing metaphysical suns.

Like pole stars for navigation, Titian and Raphael guided the greatest European painters until the end of the nineteenth century. Despite being at the head of opposing and divergent schools, the nineteenth-century masters in France, Ingres and Delacroix—one Neoclassical, the other Neoromantic—both drew on the same source, and were both inspired by Raphael.

In the same way that the most disparate artists took their cues from Raphael (Poussin, David, Ingres, Delacroix), a great tide of painters up until the great Renoir and the Italian Mancini was illuminated and stimulated by Titian this tide broke as soon as it reached our century.

The notion should not be rejected that the shredded sliver of century in which we exist with such difficulty has presented us with the hourglass of time upturned, and that it shows us things close to us as though they were at a distance and remote things as though they were not so far away. To us the nineteenth century, in spite of its vigorous formalistic exploits, seems to us more remote (and at any rate extraneous) than any prehistoric sign or symbol discovered in the caves at Altamira or in the Dordogne.

Courbet thought at the Prado by working, and, like Ingres and Delacroix, becoming a protagonist of a tradition extolled by the museum, moved within narrow limits, in the space of a short period. In his own time, Michelangelo had already said that those who follow others can never lead.

Our point of view (through the upturned hourglass) is inevitably new, and the new painting of the twentieth century (compared with that of the nineteenth), which is young and dynamic, has other problems and sets itself other objectives. Whether it draws on the magma, in the unlimited probing of the subconscious, or proceeds by means of elective affinities in its exploration of the jungles and labyrinths of popular cultures, Africa, New Guinea, Nuragic, or Pre-Colombian, or whether it consults the enigmas of the car, comics, photography, or polystyrene foam, it can only signify the acceptance of its own human and historic condition and the passionate desire to express it. And as this human and historic condition is so very new, there can be no language able to represent it. It is no accident that the instrumental nature itself of painting has changed.

If these are the reasons for the temporary psychological and technical disinterest of the major modern painters in those great masters who, like Titian, illuminated for centuries, like suns, the seasons of art, then I wonder, with the Poet: *"renaîtront-ils d'un gouffre interdit à nos sondes \ comme montent au ciel les soleils rajeunis \ après s'être lavés au fond des mers profondes?"*

The memory of man stretches backwards through time, for centuries exploiting tufa, terracotta, the statuary of Carrara, Parian marble; for millennia utilizing copper, bronze, peperino rock, and porphyry. By means of images handed down to us in those long-lasting materials the generations of antiquity are able to communicate with modern man.

When we wish to study the ancients and their messages, we always turn our attention to paintings, though they reach back across a shorter period than sculpture. Although painting suffers the ravages of time more than sculpture, it too can sometimes cross large arcs of time by virtue of the traditional cycles that pass on, from generation to generation, a pictorial language almost as though it were a spoken language. I say 'almost' because a spoken language suffers continuous and very different wear, if the use that a people makes of the language—in the streets and schools, in military campaigns and courtrooms—can turn Latin into Italian in the course of not very many generations.

A pictorial language at times transcends the lifetime of its nation, as may have happened at the time of Phidias, and as might have happened at the time of Lorenzo il Magnifico, because a pictorial language is similar to a philosophical thought or religious movement.

No works have remained from the time of Pericles, yet Greek painting has thrust out tentacles from the obscurity of oblivion, from its roots to its branches, such that it has pushed aside the layers of schist, and cut through layers of Christian iconography to bloom once again, unexpectedly in Raphael's *Parnassus*, and urgently in Titian's *Bacchanalia*.
How these things happen, no one knows, or perhaps the only ones to understand are those painters and poets who have created such wonders, demiurges astounded as they listen to the Gods, anxious to relate what they hear to man. Titian knew perfectly, how these things happen and this is the aspect that struck me most strongly at an exhibition of one hundred and one of his works in Venice a few years before the last war.

From his early works to his last unfinished painting, Titian continu-ally renewed himself with growing vigor and power, so that the profound artistic freedom he exercized during his lifetime—even though it was a long one—has remained valid for at least five centuries.

Ahead of the crisis of Rubens' time, and approximately three hundred and fifty years ahead of the French Impressionists (see the *Tarquin and Lucretia* in the Albertina Museum in Vienna), Titian convened, from the depths of the collective unconscious, the diaspora of Phidias and Praxiteles to reign over the Venetian lagoon. Thus Titian's artistic career developed throughout his earthly life as though it had been his fate to live from the time of Pericles until the dawn of the twentieth century.

From the time of the Golden Fleece the anathema of Moses has smothered any aspiration to the art of painting in the long existence of the Jewish people, who, for thousands of years before the advent of Christ, entrusted the transcendence of their earthly lives and the message of the God of Israel to Sybil and the Prophets, and during the diaspora to poets, musicians and philosophers, but never, in our time, to sculptors or painters.

Remaining faithful to the law of Moses, Protestant Christianity rejected painted images anthropomorphic in nature, whereas, since its origin, Catholicism has made full use of painting to celebrate and spread first the spirit, then the authority of the Church of Rome.

The Madonna of the first altarpieces was derived from the rural *Mater Matuta*, and never has the ancient myth of the Great Mother been so extolled, so divinely celebrated as when Duccio, Martini, Giotto, Leonardo, Raphael, and Titian appeared.

But since its earliest days, on what iconographic tradition could Christianity have drawn if not the Greco–Roman one, though it was in evident contrast to the religious spirits inherited from the Jewish prophets.

· Having appropriated for itself the artistic language inspired by the greater and lesser Gods of the Ionic Parnassus (Apollo, Dionysus, Demeter,

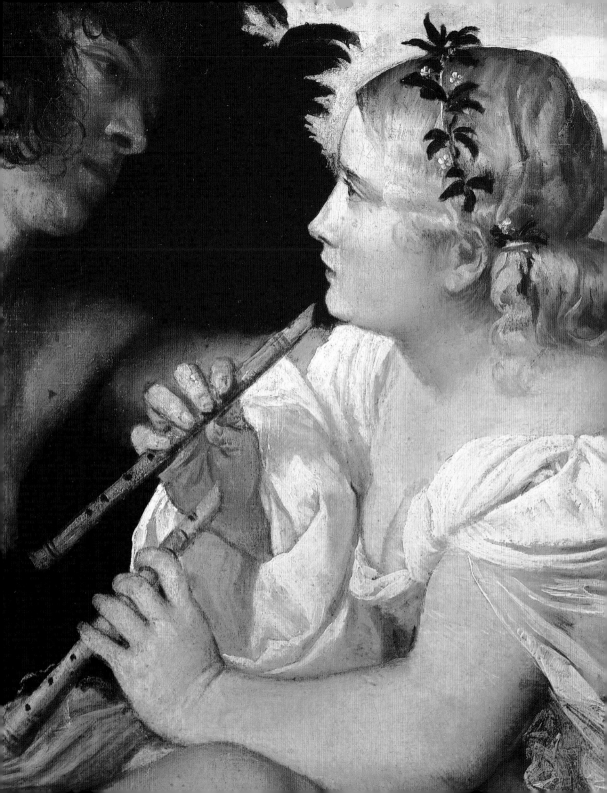

Gaia, Pan, Bacchus, and their followers), it later happened that the Church of Rome was unable to prevent this same language from betraying the purpose for which it had been employed, from moving continually further away from the Sermon on the Mount and ever closer to the Song of Songs, to David the psalmist and the prophet Isaiah.

The crisis in Florence sparked by the burning of Savonarola, when Botticelli threw his paintings on the flames, was a manifest sign of unrest, and no less was the discord apparent between the frescoes painted in the Quattrocento in the Sistine Chapel (by Signorelli, Rosselli, Perugino and Botticelli) and those painted by Michelangelo in the same chapel, first in the vault and then the *Last Judgement.*

In his fury, Michelangelo swept away banks and bridges, just as the Arno did in its floods, and his *Last Judgement*, dominated by a Jupiter rather than a Christ, is linked to the more threatening Isaiah rather than the apostle Paul (faith, hope, and charity). But in this scene, though the faith is intense, the hope is feeble, and the charity does not appear in any part of the terrible wasteland.

It was in the Europe of the Reformation and Counter-Reformation that the paradoxical episode of painting being used as *propaganda fide* came to an end even though, after the Council of Trent, many great painters and schools attempted to prolong the life of the great cycle of religious painting. But it was with Michelangelo that a period ended in which painting was subjugated less to upholding faith than temporal power, though it was from faith that it had developed. It had been a period that set Erasmus against Julius II and roused Dürer to defend Martin Luther.

Within the framework of these events, the figure of Titian towers commandingly. If as a young man he had turned down Bembo's invitation and refused to collaborate with the papal court, it was in this refusal that the vein that would later lead to the Ionic revelations of the *Bacchanal*

15

of the Andrians and *Bacchus and Ariadne* had its origin. Similarly, in later life his moral stature would not permit him to submit to the pressures of the Spanish court and even less to the moods of the Counter-Reformation.

He reacted almost absurdly to the incumbent obscurantism with the erotic and amorous charge in the *Nymph and Shepherd* in Vienna and, with the sublime *Marsyas*, the sinister voice of Ignatius Loyola seems almost to be answered by the ancient voice of Homer.

Portrait of Francesco Maria della Rovere (detail), 1536–1537 Florence, Galleria degli Uffizi

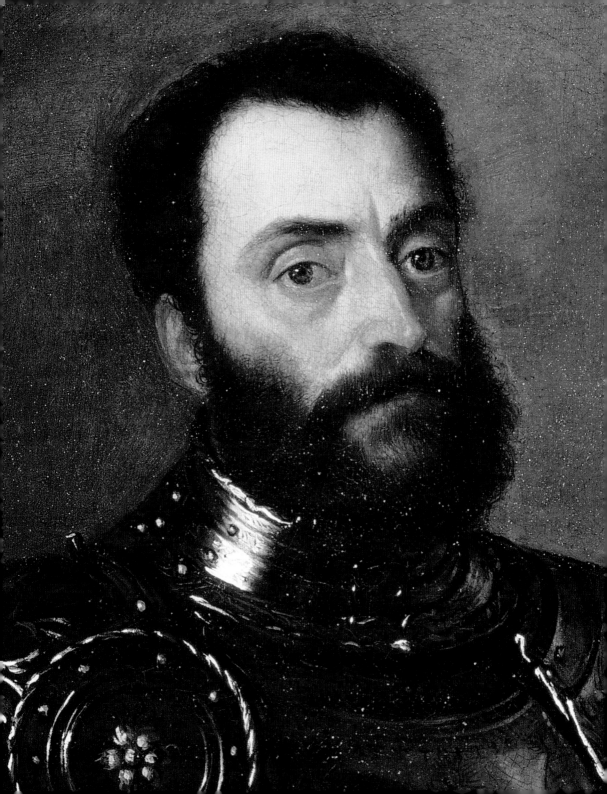

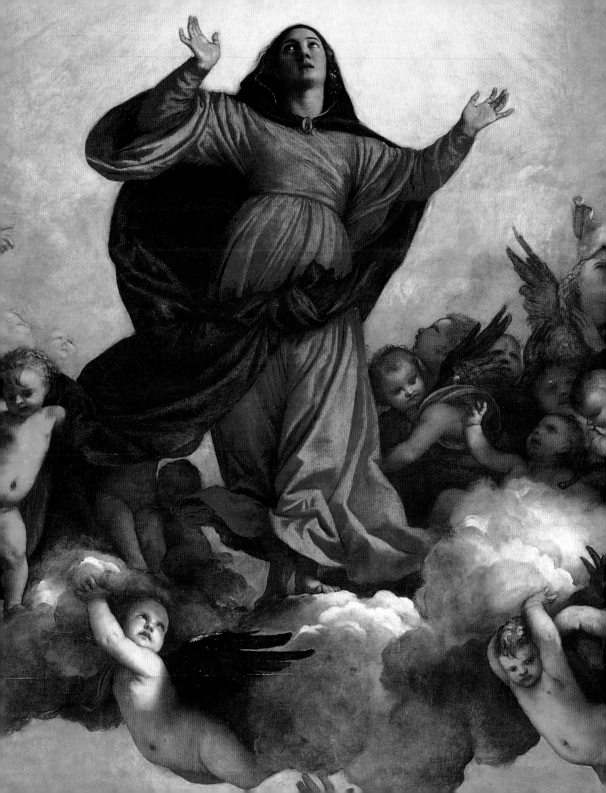

His Life and Art

Tiziano Vecellio was born in Pieve di Cadore, a small town in the Dolomites on the border with the *Serenissima Repubblica* of Venice, to a well-known and well-to-do family of ancient origin. For centuries its members had been important jurists and influential administrators of the town (the head of the family, Tommaso, a notary, had moved to Pieve di Cadore in the second half of the thirteenth century).

The artist's date of birth is uncertain: a long tradition places it at 1477, based on a letter Titian wrote to Philip II of Spain on August 1, 1571 in which he claimed to be ninety-five years old. This date, though considered valid by Borghini and Ridolfi, is today generally rejected due to the fact that the letter was written by the painter to solicit payment for several paintings and so he probably increased his age to raise the sympathy of his powerful benefactor.

Many modern critics consider Titian to have been born between 1488 and 1490 on the basis of Ludovico Dolce's *Dialogo della pittura* (1557), in which the author records that, when Titian painted the frescoes in the Fondaco dei Tedeschi in 1508, he was "not at that time even twenty years old." This fact seems to be confirmed by the—rather contradictory—information given by Giorgio Vasari in his *Lives of the Artists* (1568). At the opening of his chapter on Titian, Vasari gives the year of his birth as 1480, though later he tells us that at the time of his own visit to Venice in 1566, Titian was about seventy-six, thereby suggesting that he had been born in 1490.

But even the date given by Dolce seems unconvincing, for, being a friend of Titian, he may have wished to lower his age to make him seem particularly precocious. As for Vasari, a source who is often imprecise and contradictory, it is probable that he too got his information from *Dialogo della pittura*.

Titian's birth must have taken place somewhere in between the two dates given, in other words between 1480–1485, as argued by Erwin Panofsky (1969), Charles Hope (1980), and Augusto Gentili (1990), basing

their claims not so much on documents of the period, which are in this case of scant reliability, but rather on the deductions they have been able to draw from examination of the painter's works, in particular the early ones. Among these, of particular importance is the small altarpiece (today in Antwerp) depicting *The Bishop Jacopo Pesaro Presented by Pope Alexander VI to Saint Peter*. The painting, which celebrates the victory against the Turks at Santa Maura in August of 1502 by the combined Spanish, Venetian, and papal fleets (the latter commanded by Jacopo Pesaro), has often been ascribed to the years 1508–1512. In fact it should be dated much earlier, to 1503, shortly after the battle it celebrates, and before the death of Alexander VI Borgia (the pope who had instigated the military venture) which occurred in 1503, and was immediately followed by a sort of *damnatio memoriae*.

In addition to recognizing the painting as Titian's first work, this dating testifies to the painter's precociousness, for, having only arrived in Venice a short time before, at twenty years old, he managed to win himself a commission of great artistic and political prestige. When Titian reached Venice from Cadore in the last years of the fifteenth century, the lagoon city was experiencing one of its most splendid periods. At the threshold of the new century, Venice was one of the largest cities in Europe and, despite the recently opened route to the Indies and increasingly menacing presence of the Turks, she was the unquestioned mistress of sea trade in the Mediterranean. Although a great maritime power, the *Serenissima* also increased her territories on the Italian mainland (but not without violent clashes and internal disputes) as far as Brescia and Bergamo, encouraging agriculture and stimulating the blossoming of the *civiltà di villa* (country house civilization).

Contemporary descriptions paint Venice as a city of opulence and abundance: "Nothing is made there," wrote Marin Sanudo in his *Diari*, yet "everything—whatever you may wish for—is found in

abundance," and, according to the enthusiastic sixteenth-century diarist, the profusion of goods coming from the Levant and West ensured that everyone in the city was prosperous. Even in the literary works by the contemporary writer Ruzante, the figure of the peasant, who was always starving in the stereotyped image, in Venice was finally portrayed as replete and satisfied.

The cultural life in Venice in this period also underwent a fervid renewal: the Cancelleria di San Marco and the School of Logic and Natural Philosophy in Rialto were dynamic centers for the study of history, literature, the sciences, and philosophy. With Aldo Manuzio the lagoon city became the European capital of publishing and the center of the most refined humanism, and its aristocratic palaces housed collections of Classical antiquities. The *Serenissima*'s tolerance and proud desire to remain independent of the Holy See encouraged the influx of

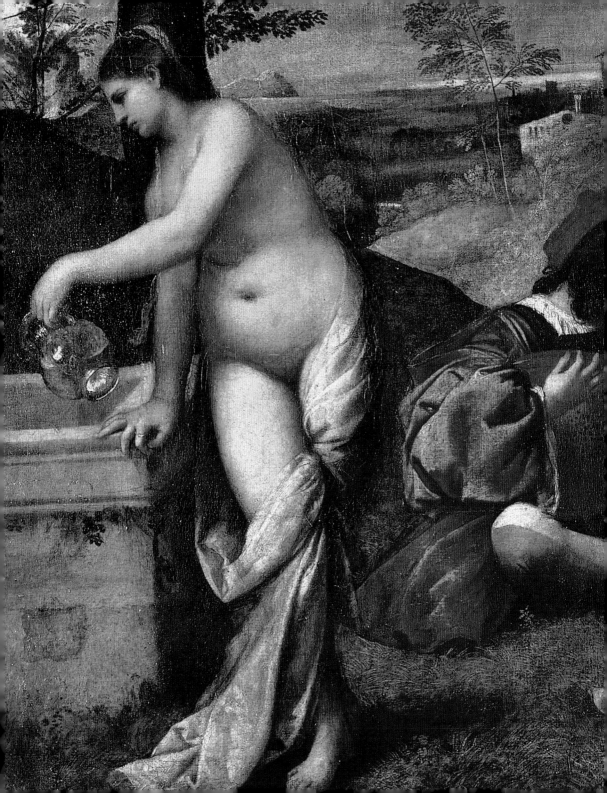

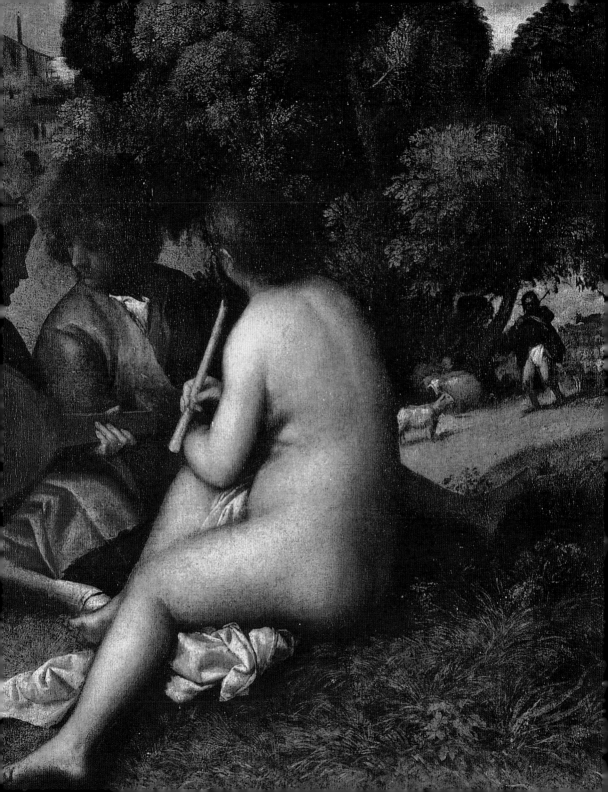

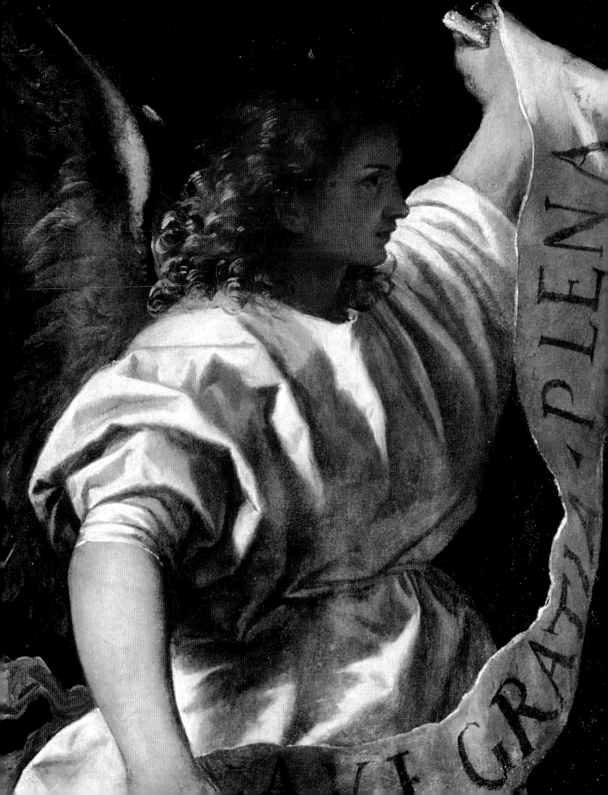

intellectuals and writers anxious to express their ideas liberally, free from the controls and conditioning of the Church.

From an artistic standpoint, Venice had passed from the elegant decorativism of the lateGothic period, embodied by the splendid Ca' d'Oro and Porta della Carta in the Ducal Palace, to the new, subdued Renaissance buildings constructed by Pietro Lombardo and Mauro Codussi. In 1500 the city welcomed Leonardo da Vinci for a short stay, and in 1505–1506 the great German painter Albrecht Dürer who, with his harshly realistic, almost Expressionistic works, had a decisive influence on the lagoon's figurative culture, though this was in any case aware of the developments in Northern, Flemish, and German art, with which it had become familiar through the widespread circulation of paintings and, above all, engravings.

Titian's artistic development had its foundation in an awareness of these new tendencies from abroad, as well as, naturally, by study of the great masters who had brought a wave of fresh air to Venice's figurative culture at the end of the Quattrocento and start of the Cinquecento: Vittorio Carpaccio, who painted the pictorial cycles for the city's schools, altarpieces and official works in the Ducal Palace; Giovan Battista Cima da Conegliano, active until 1515–1516; the young Lorenzo Lotto, and Sebastiano Luciani (later known as Sebastiano del Piombo); and above all Giorgione da Castelfranco and the brothers Gentile and Giovanni Bellini.

Many and various were the stimuli that contributed to the young Titian's development. Stories of his childhood, tinged with legend, portray a young boy in Pieve di Cadore as he paints a Madonna "with the juice of flowers." Less imaginative but not completely truthful is the information in Ludovico Dolce's *Dialogo della pittura* in which, after his early apprenticeship in the workshop of the mosaicist Sebastiano Zuccato, Titian first entered the workshop of Gentile Bellini and then that of his more

'modern' brother Giovanni, before finally moving on to work with Giorgione. The linearity of this *curriculum vitae* is, however, contradicted by analysis of the artist's first works, which reveal that he had many more models available to him and, in particular, how his debt to Giorgione was actually much less significant than was originally believed.

The small altarpiece in Antwerp commissioned from Titian by Jacopo Pesaro around 1503, which, as has been mentioned, is the first known work by the artist, confirms this claim. On the basis of stylistic considerations, Augusto Gentili (1990) has proposed that this work was painted over a long period (1503–1506). The differences in the representation of the three figures in the sacred scene reveal Titian's progressive approach, one that reflected the manners of different masters: the figure of Pope Alexander VI, painted first, was influenced by the dry, graphic, 'fifteenth-century' painting of Gentile Bellini; the brushstrokes and chromatic gentleness seen in Saint Peter, the next figure

to be painted, are reminiscent of those painted by Giovanni Bellini in his masterpieces at the start of the Cinquecento; while the splendid portrait of Pesaro himself, the last of the three, is unquestionably indebted to Flemish and German art for its vigorous realism. In consequence, the influence of Gentile and, particularly, Giovanni Bellini over the young Titian is confirmed. At the start of his career, he must certainly have painted "some portraits and para-Bellinian Madonnas", though at this point there are no evident references to Giorgione. The superb results achieved by the master from Castelfranco in atmospheric definition and coloristic fusion have induced modern art historians to attribute to him all the novelties in Venetian painting between 1500 and 1510, and to make him the author of the "naturalistic turning point" that marks the art of the lagoon in this key period. In consequence, Titian (and with him Sebastiano del Piombo) has long been considered a "creation" of Giorgione, his "son," as Vasari famously put it, in the art and trade of

Portrait of a Lady (La Schiavona),
c. 1510
London, National Gallery

painting. The traditional belief that Titian undertook an apprenticeship in Giorgione's workshop has given rise to the hypothesis that, for many undocumented works or those of difficult attribution, on the master's death in 1510, his pupil assembled those paintings left unfinished and completed them himself (amongst which, *Christ Bearing the Cross* in the Scuola di San Rocco, the *Concert* in the Palazzo Pitti, and the *Pastoral Concert* in the Louvre). This simplistic deduction, in addition to iconological and stylistic considerations that assign these works to the young Titian, contradicts contemporary sources, none of which say that Giorgione had a workshop, a school, or even pupils. The master of Castelfranco worked on a private basis, maintaining links with elite circles of humanists for whom he produced paintings founded on cultured but obscure allegories, and remained isolated—perhaps by choice, perhaps because he did not have the time to build suitable political and cultural relations—from the large public, ecclesias-

tical, and civic commissions. The approach of the young Titian was completely different: he too arrived in the capital of the *Serenissima* from the provinces but, unlike Giorgione, he was ready to lend his brush to all the demands of his Venetian clients, from those in the private humanistic circles to those of the official representatives of political and religious power.

With the 'businesslike' shrewdness that typified his artistic career, Titian quickly succeeded in winning himself prestigious and varied commissions: from the altarpiece in Antwerp to the cultured musical allegories of the *Concert* in the Palazzo Pitti and the *Pastoral Concert*, from the first portraits of Venetian aristocrats to the huge task of frescoing the Fondaco dei Tedeschi, from the *Christ Bearing the Cross* in San Rocco to the prestigious commission of the frescoes in the Scuola del Santo in Padua.

It has been pointed out that the many paintings traditionally considered Giorgione's in origin but completed by Titian were instead entirely the work of the younger painter. An exception is the famous painting known as the *Sleeping Venus* in Dresden, which was painted by Giorgione in 1507 to celebrate the marriage of Gerolamo Marcello to Morosina Pisani that same year. The master's painting of the goddess of love asleep, depicted with an idealized and modest beauty, must, however, have seemed to the client a little unsuitable as a wedding gift for hanging in the bride and groom's bedroom. Thus it was that in 1510, on Giorgione's death, Titian was asked to modify the painting, which he did by inserting details to emphasize the work's erotic dimension, first and foremost the soft, ruffled drapery on which the naked body of the goddess lies. And it was in this manner that Titian, who was never a pupil of Giorgione, took on the role of 'the new Giorgione', taking on the master's allegorism, which he inserted in a more complex cultural context, and also his colorism, which Titian expressed with a new gentleness and naturalness (Gentili 1990).

Also in portraiture Titian moved away quickly from Giorgione's models. Whereas the portraits by the painter from Castelfranco are of half-length figures separated from the observer by a parapet, Titian removed all barriers between the sitter and the observer to create a direct contact. The figures of the younger painter were also shown from the knees or waist up and were no longer immobile, dreaming characters but real individuals moved by feelings and emotions that Titian registered with exceptional acuteness and vigour.

The first work officially commissioned from Titian were the frescoes that he painted in 1507–1508 on the façade of the Fondaco dei Tedeschi. The Fondaco, which had recently been rebuilt following a fire in 1505, was a building where German merchants who visited Venice could relax and trade, though it remained the property of the Republic. Like the decorations painted by Giorgione on the façade that faced the Grand Canal of the same building, Titian's frescoes deteriorated fairly rapidly and today only fragments survive. The most important of these, which are still legible due partly to the valuable engravings made of them in the eighteenth century by Antonio Maria Zanetti, are conserved in the Galleria Franchetti in the Ca' d'Oro. Their overall range of subjects is difficult to reconstruct: Giorgione's frescoes, which were already incomprehensible to Vasari on a visit to Venice just a few decades after their completion, may have had an astrological theme, while those by Titian were political in nature. In the female figure seen in one fragment, who raises a sword before an imperial soldier, thus merging the iconography of Judith and that of Justice, one can make out an allegory of Venice, its political power and the divine protection that the city enjoyed in the years it was menaced by the League of Cambrai, of which the German emperor Maximilian was a member. It is therefore possible to deduce that Titian was given the task of inspiring the respect for the

Serenissima of the merchants who resided in the Fondaco, Germans like the emperor who in those years threatened the city's power. From a stylistic standpoint, these frescoes reveal Titian's independence of Giorgione: whereas the *Young Female Nude* painted by the latter fits harmoniously into her shaded niche, Titian's figures dynamically occupy the space in open poses with daring foreshortening.

Specific political messages were also seen in the *Saint Mark Enthroned with Saints* altarpiece, painted by Titian around 1510 for the Venetian church of Santo Spirito in Isola, and today at the Salute. Painted as a votive work during a violent outbreak of the plague, the painting was probably commissioned from Titian by the Republic itself, as is suggested by the absolute preeminence of Saint Mark, the embodiment of the *Serenissima*, at the center of the altarpiece. He is shown seated on a throne in a position generally reserved for the Madonna and Child. Thus here too Titian interpreted Venice's celebration of

itself and its political and ideological claims.

Similar observations can be made about the three frescoes painted in Padua in the Scuola di Sant'Antonio between April and December 1511. The subjects represented are all miraculous episodes in which Saint Anthony succeeds in reuniting quarreling families, and which also celebrate the reconciliation between Venice and Padua after the latter had been conquered by the Holy League in 1509 formed against the *Serenissima* by Julius II. In his Paduan work Titian displays a figurative culture that is already mature and autonomous, as is apparent from his learned references to ancient statuary, imaginative compositions and brilliant use of color. Together they harmoniously merge ideas from Giovanni Bellini and Giorgione, but also from Mantegna, Dürer, Michelangelo, and Raphael. With this commission, the painter from Cadore won himself a position of supremacy in the Venetian art world as well as public commissions of great prestige. During the same months that he was painting the frescoes

in Padua he was preparing the design for the monumental woodcut of the *Triumph of Christ*, thus establishing himself courageously in the field in which Andrea Mantegna, Albrecht Dürer, and Marcantonio Raimondi were working. The *Triumph*, of which Vasari praised the "boldness" and "lovely manner," represents, in a procession of great visual impact, the victory of Christian faith and, at the same time, allegorically celebrates the reconciliation between Venice and the Church of Rome. The painting also had a stylistic link with the culture of Rome, displaying with extraordinary precociousness the monumentality and plasticism of the inventions of Raphael and Michelangelo, which were known in Venice through the visit in 1508 of Fra' Bartolomeo and, above all, through drawings and engravings.

In 1513 Titian turned down Pietro Bembo's invitation to move to the Roman court of Pope Leo X and, in the same year, he addressed his famous petition to the Council of Ten in which, with sincerity and determi-nation, he offered himself as official painter to the *Serenissima*. After describing his origin in Pieve di Cadore and his early training in Venice, Titian declared that he was ready to paint the large canvas representing the *Battle of Spoleto* (to replace the faded fourteenth-century fresco by Guariento in the Sala del Maggior Consiglio in the Ducal Palace), which, due to the fact that it was situated against the light, as he emphasized proudly, was an under-taking that no painter had dared tackle. And asking in the same letter to be paid in cash and to enjoy the same concessions granted to Giovanni Bellini, he demonstrated that he was well aware of his value and that he believed himself worthy to take the place of the eighty-year-old master as the leading painter in Venice.

As he gradually assumed the role of official painter to the *Serenissima*, Titian moved closer to the human-istic circles of aristocrats and rich merchants active in the city at the start of the sixteenth century. The literary, philosophical and

following pages
*The Presentation of the Virgin in
the Temple* (detail), 1534–1538
Venice, Gallerie dell'Accademia

musical ideas that were developed by this elite culture were translated by the painter into exclusively private works, the dominant theme of which was the relationship between love and music; the paintings were one facet of a learned culture that sparkled with the contemporary philosophical and musical theories of Pietro Bembo, Mario Equicola, and Leone Ebreo, marked by a Pythagorean and Neoplatonic stamp. Musical harmony symbolized the harmony of love, understood not as carnal passion but as Bembo's 'good love'; this corresponded to the desire for 'divine and immortal' beauty and was associated with the 'noble' string instruments that were the emblem of refined, cultured, city-dwellers' music, the harmony of which is often threatened by disorder and carnal instincts. This was the theme of the famous *Pastoral Concert* of 1509–1510, now in the Louvre, in which the perfect harmony between the lute played by an elegant young man and the flute held by a nude Muse is disturbed by the intrusion of a coarse shepherd. This motif is also present in the *Three Ages of Man* in Edinburgh (1512–1513): as Palucchini observed, "the teaching of the ancient masters is transposed outside of any idealized beauty or intimate dream in favor of a joyous sensation of life, which flows from the contrast created between forms extended across large chromatic fields and the splendor of sumptuous tints, within the space filled by gradations of vibrant luminous highlights and atmospheric shadows." Complex allegorical meanings are also present in the painting known as *Sacred and Profane Love* (1514–1515), which was painted as an allusive celebration of the important and unusual marriage between Niccolò Aurelio and Laura Bagarotto. These are paintings in which Titian displays all his chromatic classicism by inserting expanded forms in spaces given life by luminous highlights and atmospheric shadows, organizing vivid colors in broad fields and creating the effect of a "joyous sensation of life".

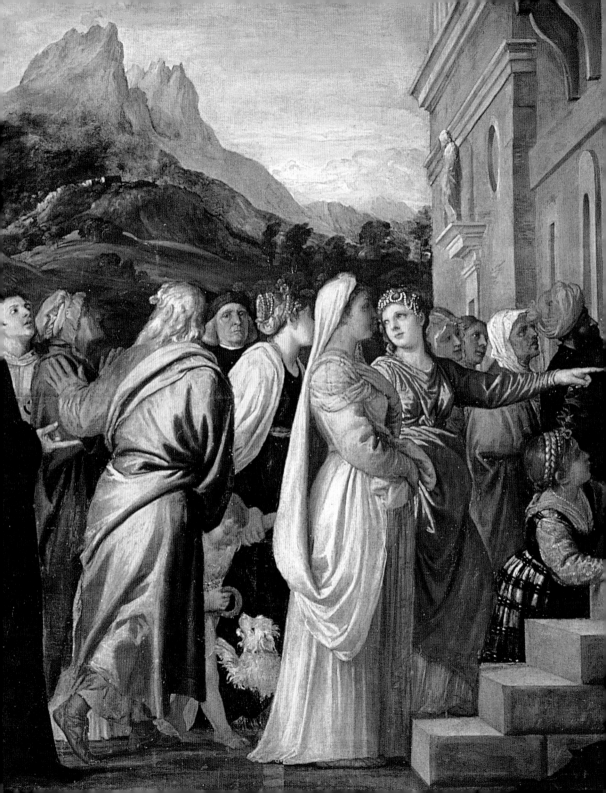

Titian tackled the theme of love and music approximately ten years later when Duke Alfonso I of Ferrara commissioned him to produce four paintings for his private *studiolo*, called the *camerino d'alabastro* (Alabaster Chamber, no longer extant) in the Estense castle. Although we do not know with certainty either the exact location of the room in the castle or the arrangement of the canvases on its walls, it is sure that Alfonso had in mind the model of the famous *studiolo* in Mantua of his sister, Isabella d'Este. The duke wanted his room to be decorated with a series of paintings of bacchanals, as traditionally Dionysiac celebrations were the opportunity for the world and history to be liberated from its troubles, so Titian executed the *Worship of Venus* and *The Andrians* (Prado, Madrid) and the *Bacchus and Ariadne* (National Gallery, London) and modified the *Feast of the Gods* painted by Giovanni Bellini in 1514, repainting the landscape and several figures in order to harmonize the scene stylistically with his own works. Titian showed in these canvases that he was able to translate those mythological themes favored by the Humanists at court into a binding program, producing compositions in which, thanks to the dynamism of the figures and the dazzling use of color, moralizing elements are portrayed side by side with a sense of Dionysian exhilaration. Several decades later, when Titian was again to paint mythological scenes, this time for Philip II of Spain, he would tackle them differently, without the optimism of these youthful 'poems'.

The altarpiece of *Assumption of the Virgin* for the high altar of the Franciscan church of the Frari in 1516 (the year Giovanni Bellini died) confirmed the attainment of Titian's success in the sphere of large religious commissions. After having patiently created for himself a tapestry of public and private relationships, Titian began to produce those large altarpieces that from this time on would represent a large part of his output.

The *Assumption* in the Frari was placed in May 1518 in a monumental marble shrine in a solemn ceremony (also recorded in Marin Sanudo's *Diari*) and immediately proved a sensation amongst his contemporaries for its iconographic and stylistic innovations. Ludovico Dolce noted how there are present "the greatness and *terribilità* of Michel Agnolo, the agreeableness and grace of Raphael, and the coloring of nature itself," and compared them to the "dead and cold things" of the Bellini brothers and the Vivarini dynasties of artists. Indisputably the grandiose conception of the altarpiece had references in the figurative culture of Tuscany and Rome, but it was enriched by an unprecedented use of color that, through vivid glows and natural contrasts, emphasizes the drama of the scene and gives it an extraordinary unity. Shortly after the *Assumption* was placed in the church of the Frari, a new altarpiece was commissioned from Titian for the same church by Jacopo Pesaro, the bishop that fifteen years earlier had contracted the artist to paint the

small Antwerp altarpiece. The *Pesaro Altarpiece* commemorates the client himself, remembering the past victory of Santa Maura, but also his dynasty through the superb gallery of portraits on the lower register. It also alludes—through a series of symbolic elements (including the two monumental columns that stand out against the sky in the background)—to the cult of the Immaculate Conception upheld by the Franciscans who were installed in the Venetian church. The spatial conception of the painting was completely innovative: it abandoned the traditional centralized, frontal view of the altarpieces to create a dynamic arrangement founded on diagonal and ascending lines.

The same masterly fusion of theological and liturgical references, on the one hand, and of allusions to personal and dynastic celebration on the other, characterized other altarpieces painted by Titian during the 1520s after the two for the Frari. Examples are the one with the *Madonna in Glory with Saint Francis, Saint Biagio and the Donor Alvise Gozzi*, which was commissioned in 1520 by the merchant from Ragusa portrayed in the painting for the church of San Francesco in Ancona (still in that city). In this altarpiece, the pyramidal construction, clearly inspired by Raphael, is given dynamism by the "truth of the lights and shadows of the late dusk that surprise the human and divine figures against the airy backdrop of the sky thick with clouds, checked below by the outline of the lagoon city." In that same year, 1520, Titian painted the altarpiece for the church of San Nazzaro e Celso in Brescia, which was commissioned from him by Altobello Averoldi, the papal legate in Venice. In spite of the archaic form of the polyptych, which was undoubtedly a requirement of the client, the painter succeeded in creating a unitary and absolutely modern work through his references to ancient and Michelangelesque sculpture (the resurrected Christ at the center is modeled on the famous Hellenistic statue of the *Laocoön*, and the Saint Sebastian in the right-hand panel is inspired by

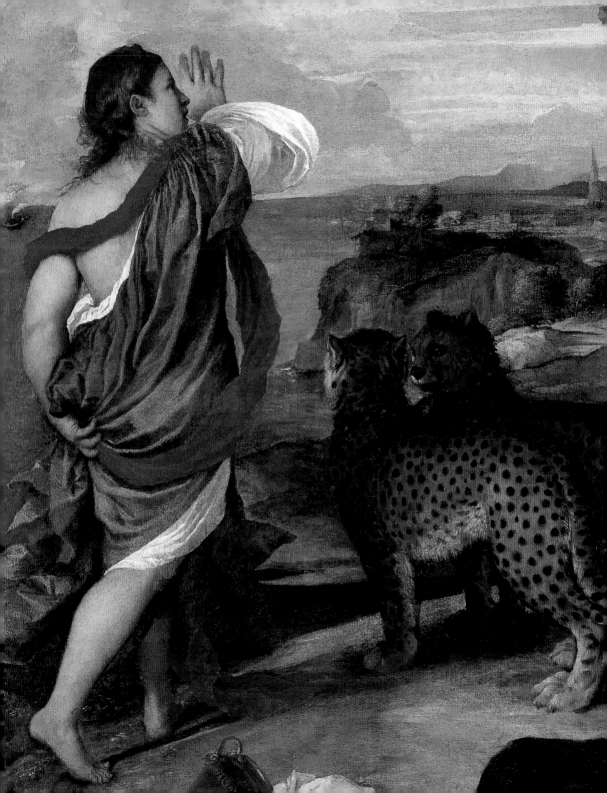

Michelangelo's *Prisoners*), and, above all, through his dynamic use of light. This element was of fundamental importance to the future developments of the Brescian school of painting.

Destroyed in a fire, the altarpiece of the *Martyrdom of Saint Peter* was painted by Titian for the altar in the Scuola di San Pietro in the prestigious central seat of the Dominicans in Venice, the church of Santi Giovanni e Paolo, where the most powerful figures in Venice, first and foremost the doges, were buried. Titian won the commission over Palma Vecchio and Pordenone. Perhaps to demonstrate his superiority over the latter, who contended with him the commissions in Venice at the time, Titian completed the large canvas in a fairly short period, between 1528 and the early months of 1530 (Valcanover 1990). Lost in a fire in 1867, the painting showed the dramatic scene of the murder of the saint as he preached at the edge of a wood, and was described by contemporaries in enthusiastic terms: according to Pietro Aretino it was "the loveliest thing in Italy" and, in the words of Vasari (1568) "the most finished, most famous and the best planned and executed, which Titian never excelled in all his life." Vasari also gave a detailed and evocative description of the painting: "He painted an altarpiece representing Saint Peter Martyr in a wood of high trees, struck down by a fierce soldier, who has wounded him in the head, and as he lies but half alive you can see in his face the horror of death, while another friar fleeing shows signs of fear. In the sky are two angels coming in the light of heaven, which lights up a beautiful landscape. The work is the most finished one that Titian ever did." Vasari's words testify to the interest Titian had developed for the relationship between the figure and landscape, something that was fully present in other religious works of the period, such as the *Madonna and Child, Saint John and Saint Catherine* (London), the *Adoration of the Shepherds* (Palazzo Pitti, Florence), and the *Madonna and Child with a Rabbit* (Louvre).

41

Portrait of Giulio Romano,
1536–1538
Mantua, Collezioni Provinciali

During the same years that he was painting large altarpieces, Titian's claim to be the *Serenissima*'s official painter was strengthened by the favor he was accorded by Doge Andrea Gritti, who was elected in 1523. Gritti was the force behind the *Serenissima*'s triumphal reconquest of Padua in 1509 and, once elected, initiated a policy of cultural promotion to revive the image of Venice as the new Rome, the capital of a magnificent empire, heir to the Rome of the East (Constantinople), which had been won from the Turks in 1453, as well as heir to papal Rome, which had been sacked by the Lanzichenecchi (the imperial troops) in 1527. The leading figures in this project for *renovatio urbis Venetiarum* were Titian and two Tuscans, who had arrived in the capital of the Republic in the year of the Sack of Rome. The Tuscans were the great writer and pamphleteer Pietro Aretino and the architect Jacopo Sansovino, who immediately formed a strong and productive partnership with Titian to create a sort of 'artistic triumvirate'

that was destined to control all the *Serenissima*'s cultural life in the middle decades of the sixteenth century. The glorious new design by Sansovino for Saint Mark's Square and accompanying Piazzetta, with the creation of an unbroken line of buildings based on Classical architecture, from the Mint to the Clock Tower, was for Titian confirmation and a stimulus for him to develop his own artistic language on a refined level. Echoes of Sansovino are clearly perceived in the superb Classical architecture that frames the scene in the *Presentation of the Virgin at the Temple*, which he painted between 1534 and 1538 for the Sala dell'Albergo della Scuola Grande di Santa Maria della Carità (today part of the Gallerie dell'Accademia). Like Sansovino's designs for the city of Venice, in his paintings Titian interpreted the heroic and imperialistic ideology of Andrea Gritti. This explains why the doge had such a preference for Titian, to whom he entrusted important works for the Ducal Palace: examples are the monumental fresco of Saint Christopher,

painted in 1523 on the wall of the stairway in the doge's apartment, that symbolizes the power of the Republic; the doge's official portrait for the Sala del Maggior Consiglio and the votive painting for the Sala del Collegio, both of which were destroyed in the palace fire of 1577; the frescoes for a chapel inside the Palace, also lost; and finally the battle scene in the Sala del Maggior Consiglio that Titian had offered to paint back in 1513 to replace Guariento's *Battle of Spoleto*, but which probably, as Pallucchini (1969) suggested, on Gritti's wishes represented the Venetians' most recent victory (1508) over imperial troops, which took place close to Cadore, Titian's home town. This fresco too was lost in the 1577 fire, but an ancient copy in the Uffizi, preparatory drawings, and engravings reveal that the composition must have had "a proclaimed tension of motions and gestures in violent movement." Titian also painted the splendid portrait of Andrea Gritti (Washington, D.C.) several years after the doge's death in 1538, which provides a heroic and vigorous image of the man.

However, Titian's most important and influential relationship was undoubtedly with Aretino who, with his letters and writings addressed to the powerful throughout Europe, championed the greatness of his painter friend, and who in turn derived consistent benefits from Titian's growing success. One of the most eloquent proofs of this partnership is the wonderful portrait that the artist painted of Aretino around 1545 (Palazzo Pitti), in which he captured forcefully and with immediacy the writer's physical and spiritual aspects. Aretino was struck by "terrible wonder" as he considered the portrait "which breathes, whose pulse throbs and spirit moves in the way I do in life." Aretino and Titian shared aesthetic ideals, as is demonstrated in a famous letter of 1544 in which the writer's words conjure up the same images as those in Titian's paintings: "With my arms resting on the window frame […] I began to watch the wonderful spectacle of the infinite boats, which were carrying as many foreigners as oarsmen; they were reflected in the Grand Canal, which recreated the image

of all those that plied it […]. And while these groups of people and others who with happy applause went on their ways, here was I, by now bored with myself and not knowing what to do with my mind or my thoughts, and I turned my eyes up to the sky; which, since the day God created it, was never so embellished with gradations of shades and light. The air was just what they who envy you [Titian] would like to be capable of reproducing. You see, in my description, the buildings that seemed to be made of artificial material rather than real stone. You see the air, which in some places I saw so pure and vivid and in others turbid and faded. Think also of the sense of marvel that I had in seeing clouds of condensed humidity, which in the principal view hung close over the roofs of the buildings, while on the furthest perspective plane they appeared halfway, and the right-hand side were filled with a *sfumato* that tended to blackish grey. I was amazed at the variety of colors in the buildings: the closest ones burned with the flames of the sun's light; the furthest were inflamed with a minium not so ardent.

Natural brushstrokes painted the sky and pushed the air away from the palaces with the same technique that Vecellio uses when he paints landscapes! A greenish-blue was seen here and there, in other places a bluish-green composed of the strangenesses of Nature, the master of the masters. With pale and dark tones she produced effects of reliefs and backgrounds such that I, who knows how your brush is the spirit of her spirits, three or four times exclaimed, 'Oh Titian, where are you?'."

The praise lauded by Aretino on Titian contributed to increasing the fame and demand for his friend's paintings, in particular for portraits. The execution of the portrait of Emperor Charles V, in 1533, brought the painter prestige and privileges that consecrated his fame throughout Italy and Europe and opened the way to a series of commissions of major importance. The fame that Titian achieved was also confirmed by Ludovico Ariosto who, in his 1532 edition of *Orlando furioso*, numbered the artist among the great painters of the modern age capable of emulating

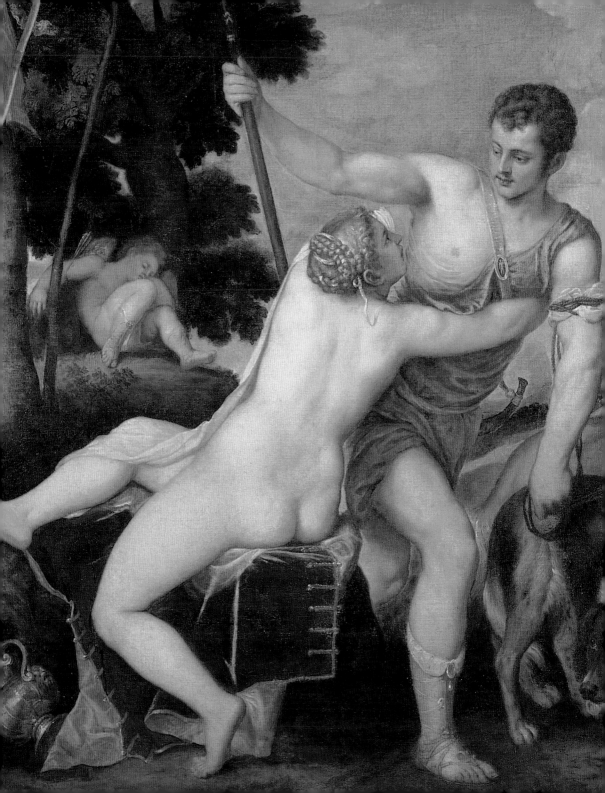

the masters of antiquity: *"Leonardo, Andrea Mantegna, Giambellino, / duo Dossi, e quell ch'a par sculpe e colora / Michel, più che mortal Angel divino, / Bastiano, Rafael, Tizian ch'onora / non men Cador, che quei Venezia e Urbino."*

Among the most important portraits Titian painted from 1530 onwards were those of Doge Francesco Venier, King François I of France, the Great Elector of Saxony Johann Friedrich, the Marguis of Mantua Federico II Gonzaga, and the Spanish monarchs Charles V, Isabel of Portugal and Philip II, with whom he was to have a privileged relationship, and the politicians, functionaries, and military men linked to them (the Granvelles, Alfonso d'Avalos, and Diego Hurtado de Mendoza). Also of unquestionable interest are the works Titian painted for the dukes of Urbino: these were the two superb portraits painted in 1536–1537 of the military *condottiero* Francesco Maria della Rovere, in glinting armour and with an 'awesome' gaze, and his wife Eleonora Gonzaga (both in the Uffizi), which Aretino described in two sonnets; and the famous *Venus of Urbino*, which was commissioned from Titian by Francesco Maria's son, Guidobaldo II della Rovere. Painted in 1538, the *Venus* reveals the great distance that separated the now mature painter from the famous *Venus* in Dresden by Giorgione, which was executed by the old master in 1507 and partly repainted by Titian in 1510. In contrast to the ideal beauty of the earlier Venus, who we can contemplate at our ease as she sleeps in the peace of nature, the painter from Cadore offers the sensuality of a real woman who, stretched out on a rumpled bed and with her hair falling loose on her shoulders, gazes seductively at the observer. She is surrounded by the standard attributes of the goddess (roses clutched in her right hand and the pot of myrtle on the windowsill) but she is also accompanied by realistic details that create an atmosphere of knowing intimacy (the small dog curled up on the bed and the ladies-in-waiting who pull out sumptuous clothes from the wedding chest). The painting, which makes a remark about the importance of eroticism within marriage, was commissioned

by Guidobaldo, who in 1534 had married, for political reasons, the ten-year-old Giulia Varano da Camerino. Now that she had reached adolescence, it is probable that it was his intent to persuade her, by means of an appropriate and culturally prestigious model, to take their marriage from the level of a political alliance to that of an amorous union. And Titian, "as on other occasions, entered into the game with a masterpiece of eroticism and functionality, but also of elegant disguise".

The works painted by Titian between the end of the 1530s and the mid-1540s are typified by attention to their formal characteristics and echoes of the Mannerism of Tuscany and Rome in their sculptural and design aspects. In fact, Titian had been aware of the refined and 'modern' language elaborated in central Italy for some time through his contact with the Michelangelesque dynamism in the painting of Pordenone; the works of Buonarroti and Raphael that he knew of through engravings; the architecture in Mantua of Giulio Romano, who was active at the Gonzaga court from 1524; the reflections of Sebastiano Serlio and the Classical designs of Sansovino; the ancient sculptures in Venetian collections; and the Classical and modern works of art he had seen during his stays at the courts of Italy (for example, the paintings by Correggio in Parma). Titian's mannerism is not, therefore, to be considered "an accident, a turning point, a crisis, nor does it depend only on the direct opportunities he had in Venice: it was rather an experimental passage through the artistic experiences and languages available to him, an episode that he very quickly set in motion and completed, and the reintroduction of those experiences and languages, to bring his cultural knowledge up to date and enrich his expressive capability, into the established practice of the Venetian pictorial tradition". It should also be mentioned that the direct contact between Titian and Tuscan and Roman painters was made possible by the arrival in Venice of Tuscan artists like Francesco Salviati and his pupil Giuseppe Porta in 1539, and Giorgio Vasari in 1541, and by Titian's stay in Rome in

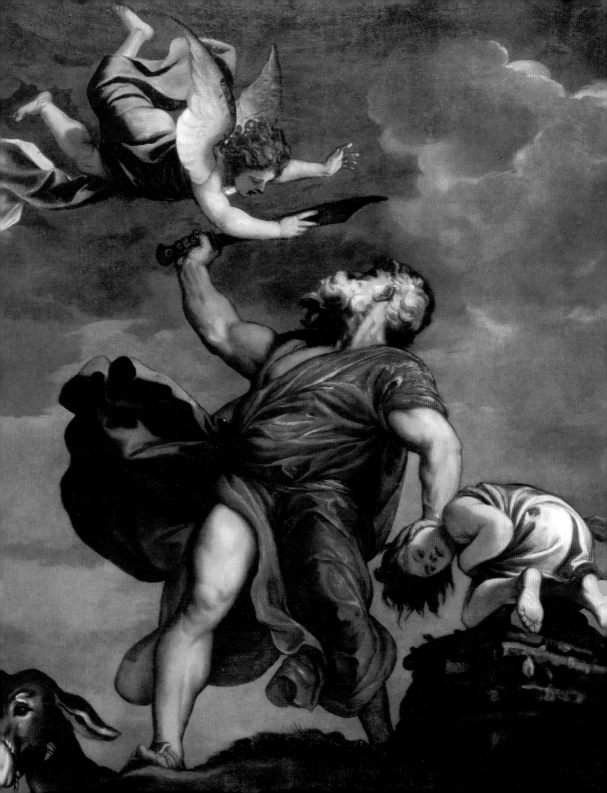

1545–1546. At the time that the central Italian artists arrived in Venice, Titian was once again the only protagonist in the city owing to the death of Pordenone in 1539, the increasingly infrequent presence of Lorenzo Lotto, and the fact that Girolamo Savoldo pursued his artistic research in an evermore isolated fashion in the direction of "everyday naturalism founded on the vital objectivity of light." Titian showed that he could embrace the innovations of the Mannerist language, the sculptural volumes, artificial poses, daring foreshortenings, strong chiaroscural contrasts, and then reabsorb them in his own unique language, rejecting the coldness and abstraction of the Tuscan artists and enlivening his compositions with a naturalistic and sensual use of light and color. As Panofsky wrote, "all these 'influences' only served to nourish his originality. No other great artist appropriated so much while making so few concessions; no other great artist was so flexible while remaining completely himself."

The best canvases by Titian in this period reveal the combination of systematic formal and 'academic' research on the one hand, and his rich organization of light and color on the other; with these—in the debate that revolved around art and aesthetics in Venice—Titian launched a sort of proud challenge, producing a series of works that exemplified the possibility of merging Tuscan 'design' with Venetian 'coloring'." The most famous works of these years can be interpreted in these terms: the *Saint John the Baptist Altarpiece* (c. 1540) painted for the church of Santa Maria Maggiore and now in the Accademia in Venice, in which the sculptural figure of the saint stands in a studied pose in a beautiful landscape bathed with glorious, glowing light; the refined scene of the *Alfonso d'Avalos Addressing his Troops* (1540–1541), today at the Prado; and the first version of the *Christ Crowned with Thorns* (Louvre), painted in 1542–1544 for the Milanese church of Santa Maria delle Grazie, in which the powerful figures in Michelangelesque pose are placed in an architectural setting similar to the Mantuan creations of Giulio Romano.

In the meantime, in 1542, Titian managed

to win the favor of the powerful Farnese family by painting the portrait of the twelve-year-old Ranuccio, the son of Pier Luigi Farnese, the commander of the papal army and nephew of Pope Paul III. From this moment on the family commissioned important paintings from him and persuaded him to transfer to Rome. Titian left Venice in September 1545 and, after a short stay in the Marches as the guest of the Duke of Urbino, Guidobaldo II della Rovere, he reached the capital on October 9. Welcomed with great honors at the papal court, he was accompanied by Giorgio Vasari and Sebastiano del Piombo on his visits to the monuments in the Eternal City (in a letter to Charles V he spoke enthusiastically of the "very marvellous ancient stones"), and met Michelangelo. Despite the festive welcome, the sensual naturalism and chromatic freedom of his painting were not understood by the artistic milieu of Rome, as Vasari testified (1568) when he spoke of Michelangelo's reservations about the *Danaë*, which Titian completed in 1546 in the Belvedere for Cardinal Alessandro Farnese (Gallerie di Capodimonte, Naples): "One day Michael Angelo and Vasari went together to see Titian in the Belvedere, and he showed them a picture he had just painted of Danaë in the shower of gold, and they praised it much. After they had left him, talking over Titian's work, Buonarroti commended him greatly, saying that his color pleased him, but that it was a mistake that at Venice they did not learn first of all to draw well, for if this man, he said, were assisted by art as he is by nature, especially in imitating life, it would not be possible to surpass him, for he has the finest talent and a very pleasant, vivacious manner." This substantial incomprehension explains why, during his stay in Rome, Titian was mostly busy as a portraitist, *in primis* by Pope Paul III, who had himself painted in the company of his nephews Alessandro and Ottavio Farnese. In this canvas Titian demonstrates how far removed he was from the cold, controlled works of the central Italian mannerists in his transformation of the fixed, rigid 'state portraits' into 'action portraits' that were almost narrative in character. The

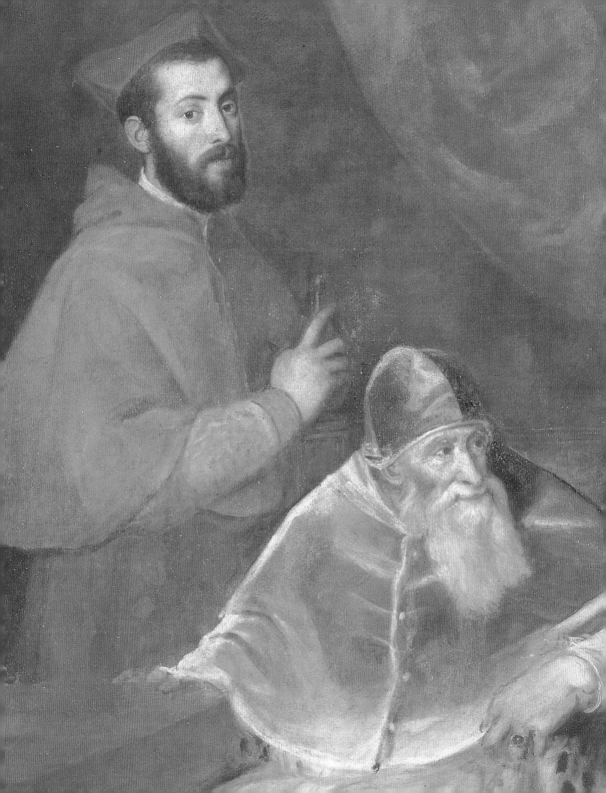

subtle psychological study of the three characters was made by means of rapid, vibrant brushstrokes of thick, dense color that were radically different to the smooth, almost metallic expanses of contemporary Roman and Tuscan artists. The truthfulness of the representation and atmosphere of understated disquiet caused the three illustrious members of the family portrayed to prefer individual, more 'official' portraits of a less psychological nature, like the portrait of Alessandro Farnese, also in the Gallerie di Capodimonte.

The solemn conferral of Roman citizenship on Titian on March 19, 1546, concluded his stay in the papal city. After a brief stop in Florence, he returned to Venice where he took up once more the works he had left unfinished, using a style enriched by his experiences in Rome (consider the references to Classical architecture in the *Martyrdom of Saint Lawrence* for the church of the Jesuits or the similarities with Bramante's design for Saint Peter's in the *Pentecost,* now in the Salute in Venice), but constantly featuring new ideas in the rendering of light and application of color.

In January of 1548 Titian left Venice again, in the company of his favorite son, Orazio, and Lamberto Sustris, to go to Augusta where Charles V had convened the princes, dukes, counts, and electors of his empire riven by the Lutheran reforms. No sooner had he arrived in the Swabian city than he was engaged to paint a set of portraits of the important political figures gathered there, first and foremost, the famous painting of Charles V on horseback, in which the emperor is shown proudly but tiredly examining the battlefield at Mühlberg following his victory over the Protestant forces there in 1547. During the same period Titian painted the declaredly erotic *Venus with Cupid and an Organist* (Prado, Madrid) for Philip II, the son of the emperor, of which two variations were made (one also in the Prado, the other in Berlin). Titian continued the practice of honoring the client in this painting by adding the features of Philip II in the face of the organist who turns to admire the florid nude figure of the goddess.

Returning from Augusta to Venice in October of 1548, Titian found himself working alongside the young Tintoretto who, during the master's absence, had painted his first important public commission, the *Miracle of Saint Mark Freeing the Slave*, for the Scuola Grande di San Marco (1548, Accademia, Venice). Jacopo Robusti (Tintoretto)—who, it was said by contemporary sources, frequented Titian's workshop for a short while—had met the requirements of the Scuole Veneziane with his forceful, spectacular, and at times visionary style developed following his encounter with mannerist culture. At the same time, Paolo Veronese established a monopoly on the decoration of mainland villas, a field in which Titian, a painter of "declared city-dwelling vocation," had no interest. The greater part of the works that Titian produced in Venice during this period were for locations of middling or modest political or ecclesiastical importance: for example, the altarpiece for the church of San Giovanni Elemosinario, in which the spatial structuring of the scene, the eloquent gestures of the figures, and the powerful torsion of the beggar's body hark back to the mannerism of Michelangelo. It is a work in which the dense atmospheric veil that enwraps the figures, the rudimentary spread of the color, and the smoothening and simplification of the chromatic timber heralded the experimentation that would culminate in the revolutionary works of his last years.

From the 1550s one notes how, with regard to Venice, "Titian progressively lost that attentive commitment, that functional willingness on which he had built his success and credit; or, from another point of view, it was as if the city—through its dominant class, and political and ecclesiastical institutions—progressively withdrew from him that credit to pass it to others." The traditional assertion that throughout his life Titian was the unquestioned dominator of the political scene in Venice must therefore be corrected. From that time on, Titian was increasingly occupied fulfilling commissions from Charles V and then Philip II of Spain, and for the Iberian merchants for

whom the artist painted the great masterpieces of his old age, both religious and mythological in nature, in which he developed a new, summary, and impressionistic style *ad litteram*.

Of the works that Titian painted for Philip II are the mythological subjects he painted between 1554 and 1576, the year of his death. More than thirty years separated these last 'poems' from the works of analogous subject in his early career. The exuberant celebration of the joyous vitality on the Classical world, seen in his festive compositions lit by brilliant colors in the period 1510 to 1530 (for instance, the paintings for the Alabaster Chamber for the Duke of Este), was replaced by a melancholic, sometimes even tragic, study of the violence and cruelty of the ancient fables. The subjects he painted were mythological stories with dramatic ends: the abandonment of Venus by Adonis due to his excessive love of hunting was the prelude to his being slayed by a ferocious wild boar (*Venus and Adonis*, 1554,

Prado); another hunter, Actaeon, came across Diana and her nymphs naked at the spring, and in return for this unwelcome for discovery he was transformed by the goddess into a stag and then ripped to pieces by his own dogs (*Diana and Actaeon*, 1556–1559, Edinburgh); Callisto, a hunter-nymph in the retinue of the chaste Diana, was surprised and seduced by Jupiter in a wood and nine months later, during a bath with the goddess, was brutally forced to reveal her pregnant state (*Diana and Callisto*, 1556–1559, Edinburgh).

The three paintings all emphasize the negative connotation of hunting in a metaphor of the aimless nature of human life, always at the whim of chance and the cruelty of the gods. Even when Titian painted stories with a happy ending he placed the emphasis on the dramatic moment when the victims were the object of divine cruelty: Europa on the beach, where she was playing with her handmaidens, being abducted by Jupiter who had transformed himself into a bull (*The Rape of Europa*, 1559–1562, Isabella Stewart Gardner Museum,

55

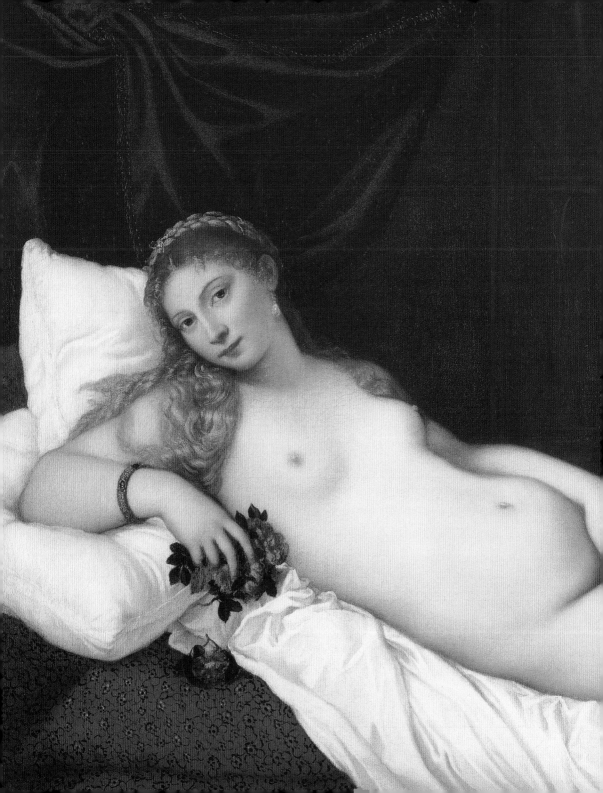

Boston); or Andromeda, guilty of boasting that she was more beautiful than the Nereids, thus arousing the anger of Neptune and in punishment being tied to a rock as a sacrifice to a terrible sea monster (*Perseus and Andromeda*, 1562–1563, Wallace Collection, London). The pessimism with which Titian treated the ancient myths, despite having looked upon them with confidence during the years of his Neoplatonism as a young man, culminated in his last two masterpieces, which he painted just before his death despite the fact that they had no particular client: the *Death of Actaeon* (National Gallery, London), which shows the tragic epilogue of the hunter struck down by one of Diana's arrows and being pulled down by his own hunting dogs as he is transformed into a stag; and the canvas in Kromeriz of the *Flaying of Marsyas*, which shows the torment that Apollo inflicts upon the Phrygian satire who defeated him in a musical contest. Augusto Gentili's penetrating study of this painting shows how Titian wanted to depict the end of the natural and primitive world embodied by Marsyas, and its replacement by the civilization and rational harmony represented by Apollo. This epochal writershed was no longer seen by the painter with the optimism of his youthful years but with a sense of sorrowful melancholy: this is confirmed in the figure of King Midas, who gloomily watches the scene. The features of the king, who was able to turn everything he touched into gold and belonged to the defeated civilization, have been identified as those of Titian himself: the identification of Midas-Titian clearly confirms that the judgement of Midas is the judgement of the artist himself, 'foolish' not for having refused the supremacy and authority of the god but, as the sparkling crown on his grey hair explains, for having believed in the illusion of the golden touch. The long illusion of the 'golden touch' of the great painter, and his long-held belief in the importance of transmuting [painting] matter into a precious image, extinguished by the final awareness of the absolute irrelevance of art when faced by the adversity of history."

MOYSES

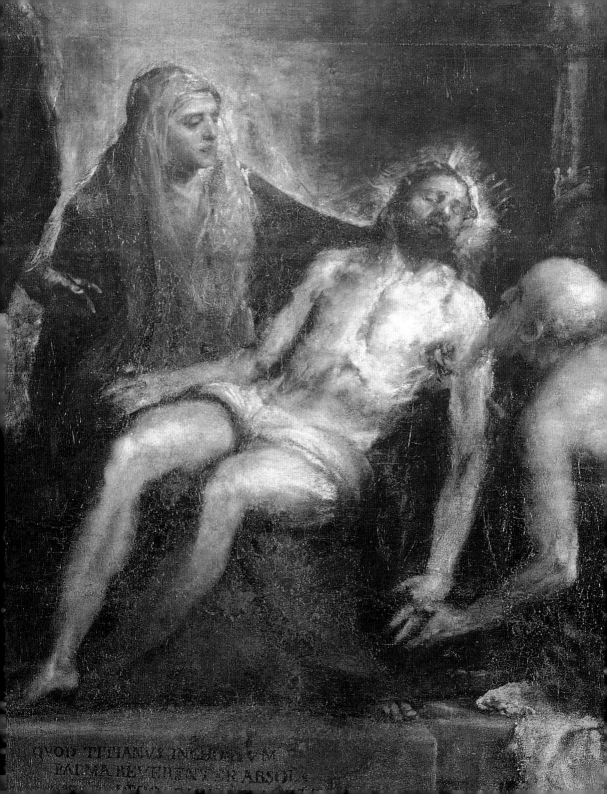

QVOD TITIANVS INCHOATVM
PALMA REVERENTER ABSOL

Pietà
(detail), *c.* 1575
Venice, Gallerie dell'Accademia

Unsurprisingly, it was in the artists, last 'poems', as in his allegorical and religious works produced during his last years, that Titian's style achieved extraordinary results in its freedom of expression and application of the paint. The technique that typified his last works interpreted and accentuated his sense of pessimism and the dramatic nature of the scenes represented: the range of colors was smoothened and muted to golden-brown tones of ochre and brown, and close examination reveals innumerable gradations and unexpected highlights. Titian almost completely abandoned design in his compositions and the color was applied on the canvas with rapid, vibrant brushstrokes, often simply approximate, in dense, thick treatments. Many details were left sketchy, created with rapid touches of the brush, and even with his fingers. The procedure used by the old Titian was masterfully described in the famous passage by Marco Boschini (1668) based on the direct description provided by Jacopo Palma the Younger, Titian's pupil: "Giacomo Palma the Younger told me [...] that he smoothened his paintings with such a mass of colors that they served (so to speak) as a bed [...] on top of which he was to build; and I too have seen brushstrokes resolved with thick colors, at times with a streak of pure red earth, and which served him (so to speak) as a half tint: at other times with a brushstroke of white lead, made with the same brush, tinged with red, black and yellow, he would bring out a pale area, and with these doctrinal precepts in just four brushstrokes he could make the promise of a rare figure emerge. After having built these precious foundations, he turned the paintings to the wall and left them at times for months without seeing them: and when he again wished to apply his brush, he would examine them very carefully as though they had been enemy capitals, to see if he might find some effect in them, and discover anything that did not agree with his delicate intent, like a charitable surgeon looking at a patient [...]. Thus acting, and reforming those figures, he reduced them to the most perfect symmetry able to represent the

beauty of nature and art; and after doing this, turning his hand to something else until they were dry, he would do the same again; and from time to time he covered the living flesh with those extracts of fifth essence, reducing them with many repeat performances until all that they lacked was the breath of life, he never made a figure at the first attempt […] The last touches consisted in the smudging with his fingers of the edges of the pale-coloured zones to create half tints. and combining one tint with another; at other times with a smudge of his fingers he would place a touch of darkness in some corner to strengthen it, and some smudge of red, almost a drop of blood, to invigorate some superficial sentiment, and so he would reduce to perfection his animated figures. And Palma told me truthfully that in the details he painted more with his fingers than with his brushes."

Many of his masterpieces from his old age betray this revolutionary pictorial technique, something that was generally not understood by his contemporaries and which has only been reassessed in modern times: consider, for example, the revision of the subject in the *Christ Crowned with Thorns* in Munich (a subject he had previously worked on in the 1540s in the painting in the Louvre); the *Saint Sebastian* in the Hermitage, in the indeterminate setting of which it seems as though "the earth, water and air had returned to the state of primitive chaos"; the violent scene in the Vienna version of *Tarquin and Lucretia*; and Titian's pictorial testament, the *Pietà*, now in the Gallerie dell'Accademia in Venice, which the artist painted for his own tomb. This dramatic painting, produced as a large votive offering to beseech divine protection for himself and his son Orazio during an epidemic of the plague, shows Titian himself as the old man kneeling before the leaden body of the dead Christ.

The plague struck the painter down shortly after, on August 27, 1576. A special measure spared his body from the common grave, but given the circumstances, Titian was buried in a hurried ceremony. In

less than five years the enormous inheritance of the most well-to-do artist of the Renaissance and one of the richest men in Venice was squandered by his son Pomponio. Titian did not leave a workshop behind him, nor a school; he preferred to make use of collaborators who did not have a personal style, and masters like Tintoretto, Paris Bordone, and El Greco only visited his studio for short periods. Nonetheless, his artistic legacy was carried forward not only by Venetian artists of the sixteenth century but all the great colorist masters of European painting: Annibale Carracci, Rubens, Caravaggio, Van Dyck, Rembrandt, Velázquez, Delacroix, and the French Impressionists, who found, in the 'chromatic alchemy' of the painter from Pieve di Cadore, the precedents for their own avant-garde research.

The Masterpieces

Averoldi Polyptych
The Resurrection of Christ
(detail), 1520–1522
Brescia, church of Santi
Nazzaro e Celso

Jacopo Pesaro Presented by Pope Alexander VI to Saint Peter

1503–1506
Oil on canvas, 145 × 183 cm
Anverse, Musée Royal
des Beaux-Arts
Signed 'TITIANO F. C.'

The painting depicts Jacopo Pesaro, bishop of Paphos, dressed in the robe of the Knights of Malta and bearing the Borgia standard, kneeling before Saint Peter. The saint is depicted with the Gospel in his left hand and his right hand raised in blessing. He is seated on a throne upon a podium decorated with classical-style reliefs, with the keys of the Church—his attribute—at his feet. Pope Alexander VI Borgia is standing next to Jacopo Pesaro in the pose of intercession, wearing a sumptuous green cape and the papal tiara. The painting was commissioned to celebrate the triumph of the allied Spanish, Venetian, and Papal fleets over the Ottoman Turks at Santa Maura in August of 1502. The galleys depicted in the background evoke the naval victory, which several sources attribute largely to the bishop of Paphos.

The work was probably commissioned from Titian in 1503, shortly after the battle and before the death of the pope during the same year, but was completed around 1506. This date testifies to the early success of the artist who, when he was only about twenty-two years old, won himself renown in both artistic and political circles with this important commission. The lengthy period required for the completion of the painting explains the stylistic differences that can be found in its various parts. The figure of the pope was the first to be painted, and reproduces an older style based on the models of Gentile Bellini. The next to be depicted was Saint Peter, inspired by Giovanni Bellini's elaborate style typical of the turn of the century. Finally, Titian painted the splendid portrait of Jacopo Pesaro, whose vigorous realism bears witness to the shift that occurred in his painting in the space of just a few months. Indeed, this figure clearly reveals the influence that the naturalism of Flemish and German art exerted on the young Titian.

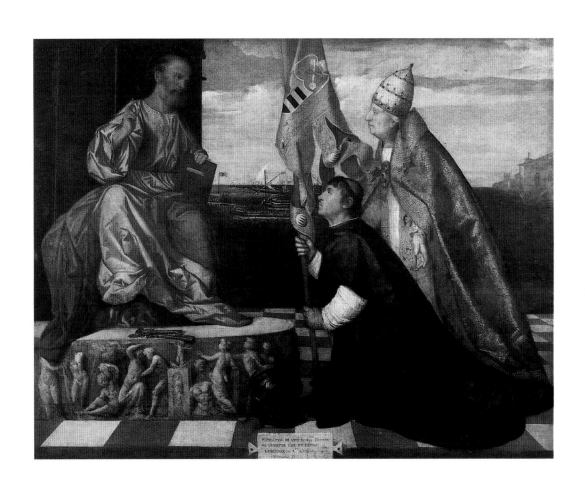

The Concert

1507–1508

Oil on canvas, 86.5 × 123.5 cm
Florence, Galleria Palatina
di Palazzo Pitti

This painting was in Venice during the time of Ridolfi (1648), who saw it in Paola del Sera's collection. In 1654 it was purchased by Cardinal Leopoldo de' Medici and was extended in the upper area at the beginning of the following century to allow it to fit the frame selected by Prince Ferdinand, who chose it for his Florentine collection in the Palazzo Pitti, where it is still housed today. Traditionally thought to have been the work of Giorgione, the painting was attributed to Titian by critics from the end of the nineteenth century and was probably painted in 1507–1508. This paternity is confirmed by several details revealed during the careful restoration that the painting underwent in 1976, as well as the theme of the concert, which the artist tackled in many works, particularly youthful ones. This subject enabled painters to play with symbolism and make erudite references to culture and the musical theories of the Venetian Humanists in an age in which musical instruction was an integral part of a gentleman's education. However, the Neoplatonic culture of Titian's period only glorified music performed with string instruments and the human voice, as opposed to the uncultured, rustic, and disorderly music of wind and percussion instruments. *The Concert* celebrates the harmony and order of 'civic' music, represented by the spinet, played by the figure in the middle of the scene, and the viola da gamba, held in the left hand of the priest depicted on the right. It has been pointed out that the gesture with which the clergyman interrupts the concert has a symbolic meaning, that of the interference of real time—which should instead be dedicated to institutionalized worship—with the ideal and perfect circular time of musical harmony. It is a topos, also related to contemporary philosophical reflections, that had already been treated by Giorgione in *The Three Ages of Man* in the Palazzo Pitti, and which Titian tackled on several occasions in such works as *The Three Ages of Man* in Edinburgh, the *Pastoral Concert* in the Louvre, and the mythological 'fables' for Alfonso d'Este.

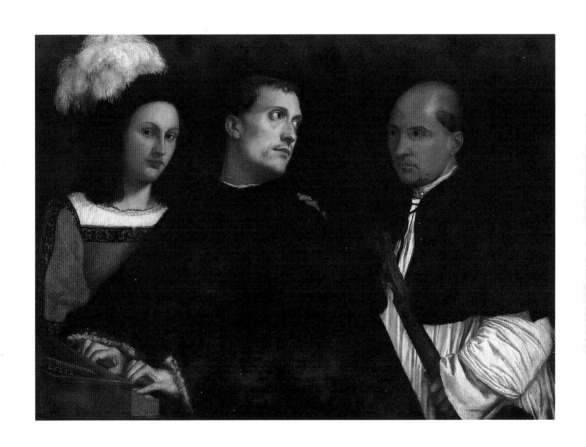

Pastoral Concert

1509–1510
Oil on canvas, 110 × 138 cm
Paris, Musée du Louvre

The *Pastoral Concert* (*Concert champêtre*, Louvre) may have belonged to Isabella d'Este before it passed to Charles I of England in 1627, and subsequently entered Louis XIV's collection in 1671. The painting was long attributed to Giorgione, or considered a work begun by him and completed by Titian. More recently critics have attributed it to Titian and dated it to 1509–1510, singling out the painting as one of the works that most clearly illustrates the ideas of early sixteenth-century Venetian musical theory and Neoplatonic humanistic culture. Indeed, the theme of this painting is that of perfect harmony between the lute, a noble and cultivated instrument played by an elegant young urbanite, and the pipe, a rustic instrument ennobled by the fact that it is used by a nude woman, probably a Muse, in an allegorical image that alludes to the superior dimension of musical harmony. A second Muse is shown on the left, performing a purification rite in which she pours water from a spring. This image refers to the mixing and blending of sounds in melodies and, according to the Pythagorean-Neoplatonic view, to the concordance between worldly and heavenly music, and the correspondence between musical harmony and universal harmony.

The concert is interrupted by the intrusion of a dishevelled shepherd who has strayed from the wood in the background, where his flock and another shepherd are portrayed. The two noble musicians turn to examine this man of lower class and culture, who has upset the sublime harmony that they have created. The painting thus uses a collection of symbols referring to the contemporary philosophical and musical theories of Pietro Bembo, Mario Equicola, and Leone Ebreo to condemn the contamination of cultivated musical genres with popular elements, while the contrast between city and country represents the conflict between the social classes and their roles.

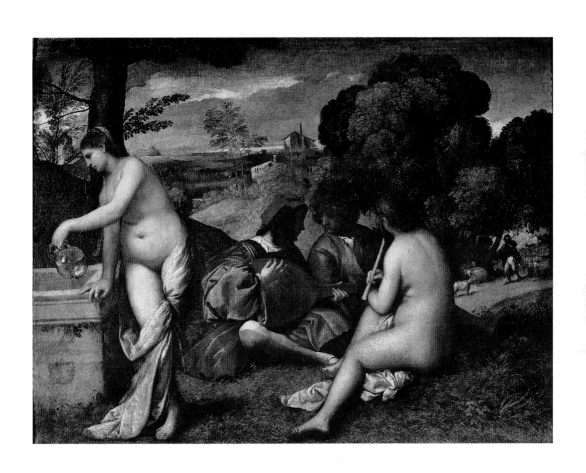

Saint Mark Enthroned with Saints

1510
Oil on panel, 218 × 149 cm
Venice, Santa Maria della
Salute

This panel was painted as an altarpiece for the Venetian church of Santo Spirito in Isola, which was served by the Augustinian canon regulars, and was transferred to Santa Maria della Salute following the dissolution of the religious order in 1656. It may have been commissioned by the Republic of Venice, as is suggested by the central figure of Saint Mark, to invoke the end of one of the many plague epidemics that devastated the city, most probably the particularly violent one of 1509. The votive nature of the work is clear from the scene depicted: to the right of the patron saint of Venice stand Saints Roch and Sebastian, who were invoked against the plague, and to the left Saints Cosmas and Damian, physicians and patron saints of the medical profession. The second thaumaturgical couple, who flank the traditional pair of Roch and Sebastian, reinforces the latter two's miraculous powers of preservation with the more material protection of the physician saints. Furthermore, these two figures were depicted with the faces of two contemporary individuals (who probably offered active assistance to their fellow citizens), seeming to add the values of science and solidarity to those of the Faith. An interesting feature is represented by the superiority given to the figure of Saint Mark: the patron saint and symbol of the Venetian Republic is seated on a throne adorned with a carpet of honor, in a position generally reserved for the Virgin and Child. This arrangement undoubtedly indicates the primary role of the patron saint of Venice, and thus the Republic, in the protection of the population from the terrible epidemic. The figures in this unusual *sacra conversazione* are positioned in a space defined by the checkered floor and the columns on the right, in an arrangement associated with fifteenth-century models. However, in this case the scene is infused with dynamism by the artist's use of light, which falls from the side to illuminate the body of Saint Sebastian, the only figure facing the viewer, and leaves Saint Mark's face in the shadow—possibly hinting at the dark times experienced by the plague-struck city.

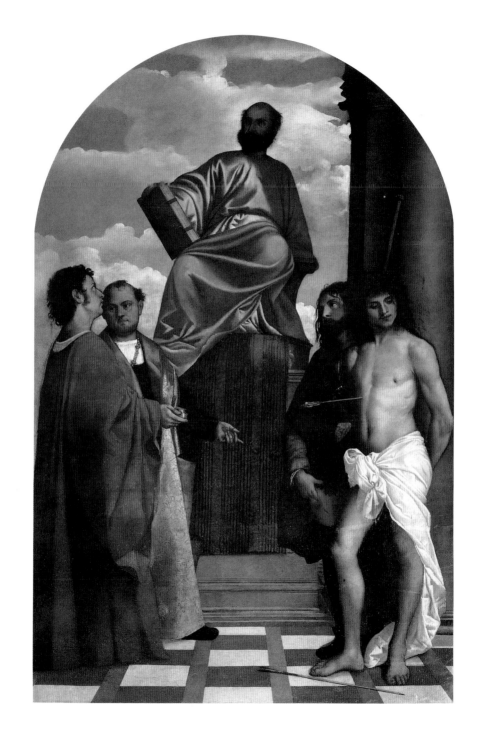

73

The Miracle of the Jealous Husband

1511
Fresco, 327 × 183 cm
Padua, Scuola del Santo

Titian painted three murals in the fresco cycle of the Scuola del Santo in Padua between April and December of 1511. The scenes represent three of the miracles of Saint Anthony of Padua: a woman unjustly accused of adultery by her husband is cleared from blame by the testimony of her newborn son (*The Miracle of the Newborn Child*); a young man who punished himself for having kicked his mother during an argument by cutting off his foot has it restored and is reconciled with his mother (*The Miracle of the Irascible Son*); a wife unjustly accused of unfaithfulness by her jealous husband is stabbed by him and subsequently healed by the saint (*The Miracle of the Jealous Husband*). The Paduan frescoes, painted in twenty-seven days, reveal the cultural complexity of the young painter. Not only do they contain learned references (an ancient statue appears in the upper left area of the scene of *The Miracle of the Newborn Child*, which has been identified as the figure of Trajan from the arch erected in his honor in Ancona or the armored figure—possibly Agrippa—depicted in the so-called *Apotheosis of Augustus* in the Museo Nazionale in Ravenna) but also feature extensive areas of deep colors and harmoniously distributed figures within the landscapes and architectural settings, revealing the extent to which the artist had already fully assimilated the lessons of Giovanni Bellini and Giorgione, along with those of Andrea Mantegna, Dürer, Michelangelo, and Raphael. The stories depicted are episodes chosen to celebrate the reconciliation and reconstruction of family affections achieved by the intercession of the saint. If viewed in the historical context in which they were painted, they appear to celebrate the renewed *pax veneta* between Padua and Venice following the events of 1509. Venice had suffered a serious political and military crisis during that year, having been excommunicated by Pope Julius II (April 27) and subsequently losing Padua to the Holy League (June 5), which was ended by the reconquest of the city by the Venetian army on July 17.

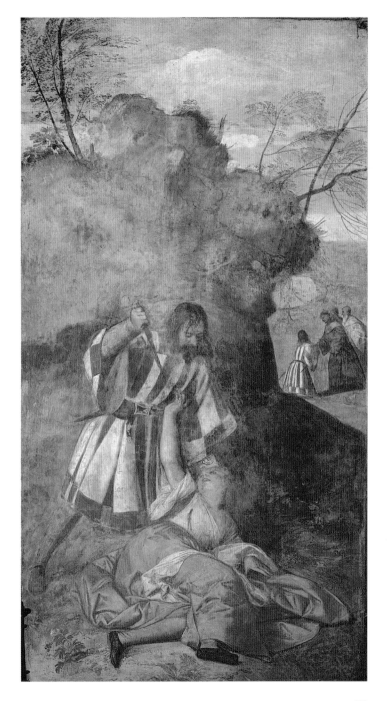

The Three Ages of Man

1512–1513
Oil on canvas, 90 × 150.7 cm
Edinburgh, National Gallery
of Scotland

This allegorical painting of the three ages of man can be dated to around 1512–1513. The work, now in Edinburgh, is generally identified with the canvas mentioned by Vasari, who wrote that it was painted for the father-in-law of Giovanni da Castel Bolognese following Titian's return from a period in Ferrara. Documentary sources testify to its presence in Augsburg and subsequently, during the second half of the seventeenth century, in the collection of Queen Christina of Sweden. In 1722 Prince Odescalchi sold the painting to the duke of Orléans, in whose collection it remained until 1798. Like other works painted in Titian's youth (such as the *Pastoral Concert* in the Louvre and *The Concert* in the Palazzo Pitti), the painting investigates and exploits the relationship between music and love, which was the focus of the meditations of the elite circles of Neoplatonic humanists active in Venice during this period. According to these ideas, Pietro Bembo's 'good love', which coincides with the desire for 'divine and immortal' beauty, is associated with the 'noble' string instruments, which symbolize orderly, cultured, and urban music, and contrasts with vain and transient carnal love, associated with the disorderly, uncultured, rustic sound of wind and percussion instruments played by peasants, shepherds, satyrs, and followers of Dionysus.

This is also the theme of *The Three Ages of Man*: on the right the peaceful innocence of childhood is represented by the slumber of the two infants, watched over and protected by Cupid; on the left, the two subjects are portrayed as a young couple, the male figure almost nude and the girl holding two rustic pipes. These two figures represent the age of youth, dominated by carnal love, to which the two abandon themselves. Finally, an allegory of old age is depicted on the slope in the background, where an old man is shown deep in thought, holding the skulls of the two young lovers, symbolizing the illusory and transient nature of their sensual love.

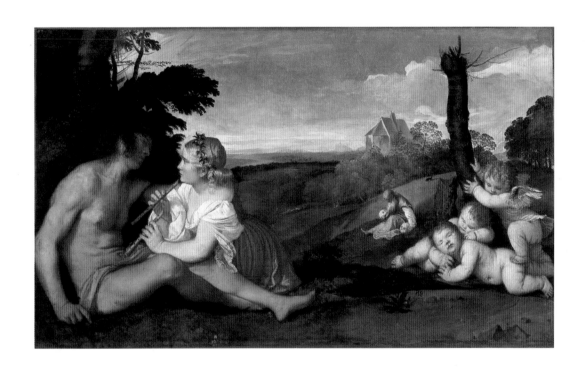

Sacred and Profane Love

1514–1515
Oil on canvas, 118 × 278 cm
Rome, Galleria Borghese

The painting known as *Sacred and Profane Love*, purchased in 1608 by Cardinal Scipione Borghese, is one of Titian's most mysterious works and has been the subject of numerous hypotheses formulated by critics of all periods. The theme of the painting, which depicts two women—one clothed and one nude—seated at a fountain with Cupid, is undoubtedly centered on love, reconciliation between life and death (the fountain is actually a sarcophagus with ancient-style has reliefs), and the contrast—tempered and resolved through the mediation of Cupid, i.e. Love—between the two female figures (the nude interpreted as Venus and the clothed as Proserpina, Polia, or earthly Venus). The painting was commissioned to celebrate the wedding of Niccolò Aurelio, an important Venetian politician, and Laura Bagarotto, the daughter of Bertuccio, a Paduan jurist condemned to death as a traitor by Venice's Council of Ten when Niccolò himself was the secretary of the Council. The coats of arms of the two families appear on the sarcophagus (Aurelio) and on the bottom of the basin resting upon its rim (Bagarotto).

The painting can thus be interpreted as an allegory of the difficulties encountered in reconciling the bride with the groom and enabling their wedding, difficulties overcome with the mediation of

Cupid and the persuasion of Venus. The clothed woman is the allegorical personification of Laura and is thus accompanied by the attributes of the bride: the white and vermilion dress, the gloves, the buckled belt, the jar of jewels, the myrtle, and the roses; in addition, a pair of rabbits, which symbolize fertility, is depicted in the luminous landscape behind her. The reconciliation of the two families through love and matrimony thus allows death to be transformed into life, and the sarcophagus—the reliefs of which depict scenes of peril and punishment—into the fountain. This celebrates the Aurelio and Bagarotto families with their coats of arms and extols their union in the roses of love that rest on its rim.

Flora

c. 1515
Oil on canvas, 79.7 × 63.5 cm
Florence, Galleria degli Uffizi

The Uffizi painting depicts a young woman traditionally identified as Flora. In the seventeenth century it belonged to Don Alfonso Lopez, the Spanish ambassador in Amsterdam, who sold it to Archduke Leopold Wilhelm of Habsburg. It remained in Vienna until 1793, when it was transferred to the Uffizi as part of an exchange of paintings. The work is a masterpiece of the young Titian and was reproduced in numerous engravings from the sixteenth century. Further proof of its fame is constituted by Rembrandt's reinterpretations of the painting, the Flora in the National Gallery in London and two female portraits now in Dresden and New York. The identity of the young woman has been the subject of much dispute. The fact that she is holding a bunch of spring flowers—probably a metaphor of love—in her right hand has led to her being identified variously as an Ovidian Flora, the goddess of spring and plant life, or the portrait of a courtesan or Titian's lover (according to tradition, Violante, the daughter of Palma Vecchio), or a nuptial allegory based on the relationship between *pudicitia* and *voluptas*, suggested by the contrast between one covered breast and the other revealed by the light blouse that has slipped down over the left shoulder. The painting is one of a series of half-figure portraits in the style of Giorgione, in which symbolic details refer to hidden meanings. However, Titian displays considerable independence from the model of the master from Castelfranco, positioning the figure in a dynamic pose rather than a rigidly frontal posture. The florid body of the young woman harmoniously occupies the space with a circular movement, traced by the gesture of her right hand offering the flowers, her left hand beneath her breast, and the slightly inclined position of her head. The well-balanced naturalness of the scene is enhanced by the soft and sumptuous use of color, which makes this painting one of the masterpieces of the young Titian's 'coloristic classicism.'

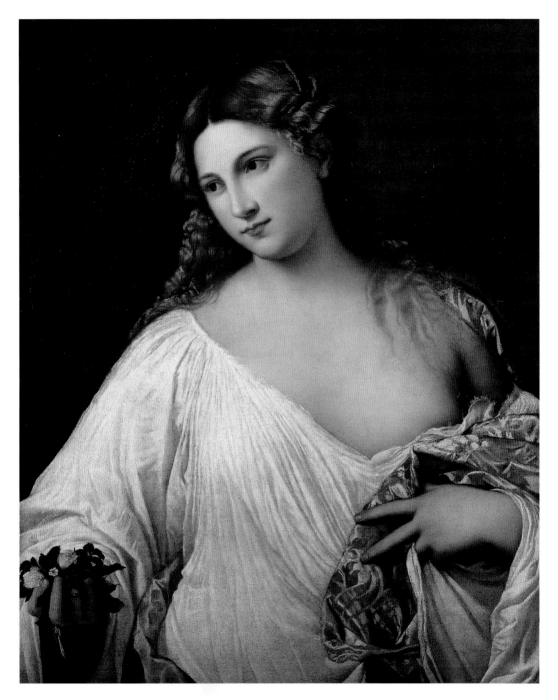

Assumption of the Virgin

1516–1518
Oil on panel, 690 × 360 cm
Venice, Santa Maria Gloriosa
dei Frari

The altarpiece depicting the Assumption of the Virgin was painted for the high altar of the Gothic-style Franciscan church of Santa Maria dei Frari in Venice for a commission Titian received in 1516. It was placed in a monumental marble niche with a solemn ceremony in May 1518 and marked the official admission of the painter from Cadore to the sphere of important religious commissions. In his scene of the Assumption, Titian created an unprecedented composition in both iconographic and stylistic terms. He abandoned the traditional references to the death, lamentation, and burial of the Virgin, preferring to represent the miraculous event of her ascension to paradise and coronation as the Queen of Heaven as a single episode in time and space in the upper part of the painting, to the joyous amazement of the angels in the center and the agitation and trepidation of the apostles at the bottom. As Rona Goffen and Rosand have noted, in this painting Titian has fused the celebratory requirements of the Venetian patriciate with the theological and liturgical views of the Franciscans (regarding the dogma of the Assumption and the cult of the Immaculate Conception) with political aspects associated with the end of the Venetian crisis that commenced in 1508 with the League of Cambrai and ended with the Treaty of Noyon, signed in 1516, the year in which the painting was commissioned.

Titian's contemporaries immediately perceived the revolutionary innovativeness of the *Assumption* in the Venetian artistic context. In 1557, Dolce noted how the panel possessed "the greatness and *terribilità* of Michel Agnolo, the agreeableness and grace of Raphael, and the coloring of nature itself," contrasting them with the "dead and cold things" of the Bellini and Vivarini dynasties of artists. The grandiose composition of Titian's altarpiece is reminiscent of contemporary Tuscan and Roman figurative art, but is enriched by a new and completely original use of color that accentuates the dramatic significance of the scene with bright flashes and naturalistic contrasts, giving it an extraordinary unity.

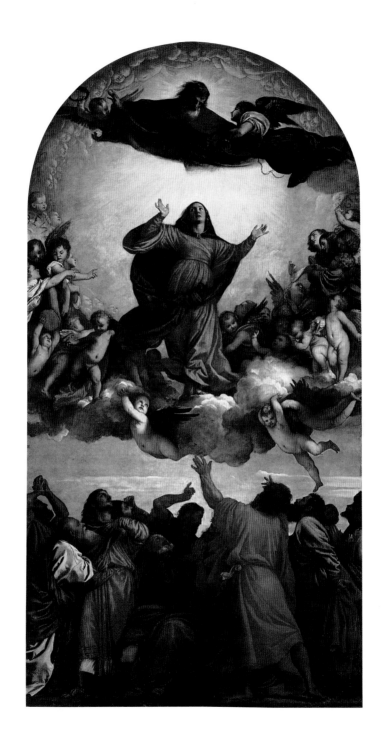

83

Madonna with Saints and Members of the Pesaro Family (Pesaro Altarpiece)

1518–1526
Oil on canvas, 478 × 266.5 cm
Venice, Santa Maria Gloriosa
dei Frari

The great altarpiece destined for a side altar of the church of Santa Maria dei Frari in Venice was commissioned from Titian in 1518 by Jacopo Pesaro, bishop of Paphos, who had defeated the Turks at Santa Maura in 1502. The naval battle, which the painter had already celebrated in the Antwerp altarpiece commissioned by the same patron in 1503, is also commemorated in this work. On the left side of the painting, alongside the kneeling figure of Jacopo being presented to the Virgin by Saint Peter, are two Turkish prisoners and a soldier bearing a standard with the Pesaro and Borgia coats of arms. In addition to the distant military triumph, the altarpiece also celebrates the Pesaro dynasty with the extraordinary group of portraits on the right. It features likenesses of Jacopo's brothers (Francesco, Antonio, Giovanni, and Fantino), which can be considered *ante factum* funerary portraits, given the destination of the altarpiece in the family's funerary chapel, and the young Leonardo, Jacopo's son, heir and scion destined to assure the continuity of the family. The fact that the altar purchased in 1518 by Jacopo Pesaro was dedicated to the Immaculate Conception explains the dominance of the figure of the Virgin in the painting. She is depicted seated on a high throne in front of two enormous columns, which penetrate the clouds and soar beyond the physical limit of the altarpiece in an explicit reference to the liturgical texts and symbolic prerogatives of the Immaculate Conception, whose cult had been promoted by the Franciscans, represented here by their most eminent exponents—Saint Francis and Saint Anthony—on the right. The Christ Child, held by the Virgin, is turned towards Saint Francis and anxiously observes the stigmata on the saint's opened arms. These prefigure the cross for which the Child is destined, which appears borne by angels above the dark cloud. The value of this altarpiece lies in the iconographic condensation of complex symbolic messages, in the rich use of light and color, and the compositional originality of the horizontal arrangement of the figures.

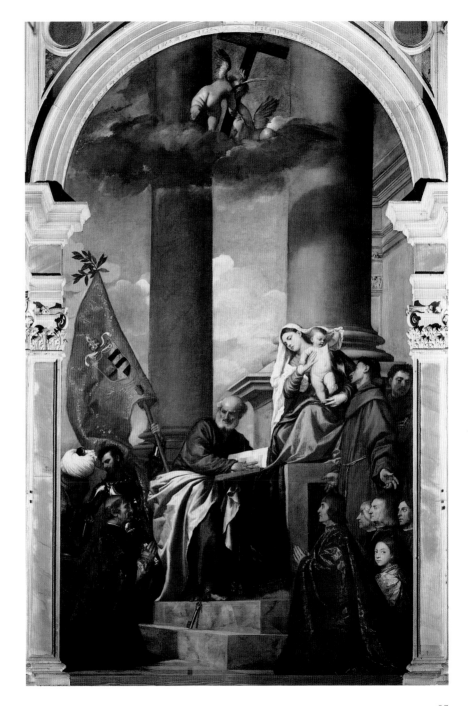

Portrait of a Gentleman
(Tommaso or Vincenzo Mosti)

1520 (?)
Oil on canvas, 85 × 67 cm
Florence, Galleria Palatina
di Palazzo Pitti
Signed and dated 'DI THOMASO
MOSTI IN ETÀ DI ANNI XXV
L'ANNO MDXXVI. THITIANO DE
CADORO PITTORE' (spurious)

This painting is considered one of the most convincing demonstrations of Titian's portraiture skills of the 1520s. It depicts a young man in an original composition that places his wide fur sleeve in the foreground. The sitter is portrayed in a frothy white shirt with a ruff at the neck, visible beneath the fur collar of his surcoat. The coat is painted in a refined interplay of greys, whites, and tones of gold and silver, while the man's face is turned towards the observer, with whom he establishes a lively dialogue through his intense gaze.

The inscription on the back of the work (which is not contemporaneous, but probably added when it was repainted in the mid-seventeenth century) describes it as a portrait of the twenty-five year old Tommaso Mosti, painted by Titian in 1526. Nevertheless, this may be incorrect, as Tommaso—who belonged to a powerful family connected with the Duke of Ferrara, Alfonso d'Este—embarked upon an ecclesiastical career in 1524 and his attire in the portrait reveals no trace of this. This has led critics to identify the figure as one of the other Mosti brothers, Vincenzo or Agostino, or to abandon all attempts at identification. However, Robertson has suggested that the incorrect information in the inscription on the back of the painting is the date rather than the identity of the figure. He claims that the work was painted in 1520 and that the date 1526 is the result of a mistake in copying the number '0', which became a '6'. This would enable the subject to be identified as Tommaso Mosti, portrayed in 1520, before entering the priesthood. This date is also convincing from a stylistic point of view (Valcanover, Rearick, Padovani): indeed, the pictorial quality, rich use of color and modern composition make this portrait similar to the *Man with a Glove*, also dated around 1520.

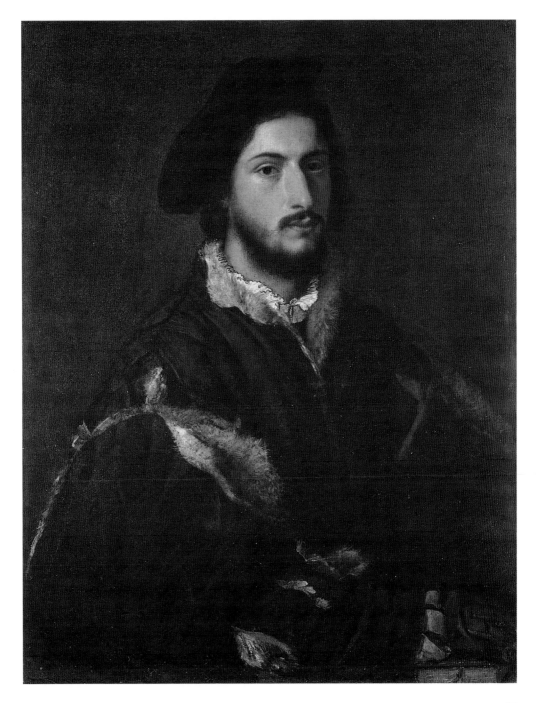

Averoldi Polyptych

1520–1522
Oil on panel,
The Resurrection of Christ,
278 × 122 cm
Saint Nazzaro and Saint Celso with a Donor, 170 × 65 cm
Saint Sebastian, 170 × 65 cm
Announcing Angel, 79 × 85 cm
Virgin, 79 × 85 cm
Brescia, church of Santi Nazzaro e Celso
Signed and dated 'TICIANUS FACIEBAT/MDXXII'

The altarpiece for the church of Santi Nazzaro e Celso in Brescia was commissioned from Titian in 1520 by Altobello Averoldi, papal legate to Venice, and completed by the artist in 1522 (the date and the painter's signature appear in the right panel, on the column beneath Saint Sebastian's foot). The typically fifteenth-century form of the polyptych was undoubtedly imposed by the client, though Titian managed to update it with a series of innovative devices, such as the convergence of the figures towards the large central scene of the Resurrection and, in particular, the dynamic use of light, with rich chiaroscuro contrasts, in all the panels. He thus managed to give a strong sense of unity to the composition, which focuses on the scene of the Resurrection, the iconography of which has unusually been combined with that of the Ascension. The sculptural resurrected Christ, whose pose echoes the famous Hellenistic statue of *Laocoön*, raises the banner of victory over death amid the astonishment of the onlookers, in a landscape enlivened by luminous gleams and chiaroscuro effects that were to have a decisive influence on the development of sixteenth-century Brescian painting (in particular the work of Moretto and Savoldo). In the left panel, the patron saints of the church for which the altarpiece was dedicated and the kneeling figure of Averoldi, depicted in the traditional donor pose, have completely lost the fixed quality of similar fifteenth-century paintings. In the right panel, the heroic figure of Saint Sebastian is depicted in his full phisical vigor and restrained energy in a completely Renaissance style that combines the grandeur of antique statuary with that of Michelangelo's slave sculptures, while an angel is shown indicating the martyred saint's wounds to Saint Roch in the landscape of the background. The two upper panels, unified by the golden light that floods the nightscape, backlights the angel, and illuminates the Virgin's face, depict the engrossed figures of the two subjects in an atmosphere of lyrical and calm intensity.

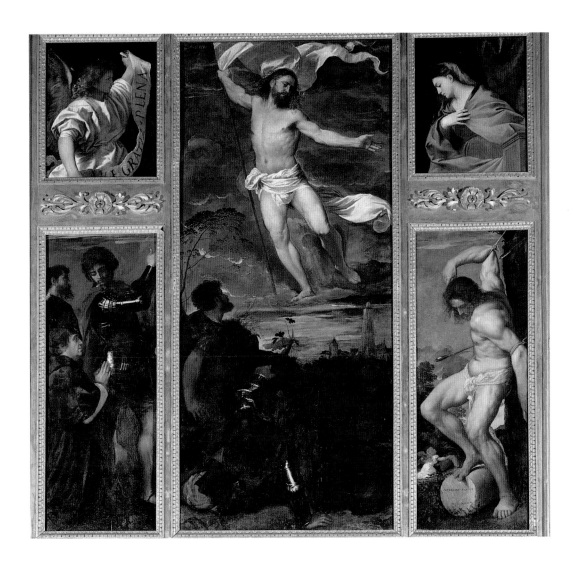

Man with a Glove

1520–1523
Oil on canvas, 100 × 89 cm
Paris, Musée du Louvre
Signed 'TICIANUS'

The painting is a half-figure portrait of young man positioned at a slight angle and set against a dark background, defined only by the block of marble on the right on which the painter signed his name 'TICIANUS'. It has been suggested that this portrait, one of Titian's most famous and highly regarded works, belonged to the collection of the Gonzaga family, but we have no certain information regarding its original location. The first documentary evidence places the painting in the Parisian collection of the banker Eberhard Jaback, who sold it to Louis XIV in 1671. It was transferred from Versailles to the Louvre in 1792.

The portrait bears witness to Titian's early detachment from Giorgione's style also in this genre. Whereas the latter's portraits feature half-length figures separated from the viewer by a parapet, Titian eliminated all kinds of barriers, creating a direct dialogue between the subject and the observer. It has been suggested that the man depicted in this painting could be the Genoese nobleman Girolamo Adorno, sent to Venice by Charles V in 1522–1523 (Hourticq), Giambattista Malatesta, an agent of the Mantuan court in Venice, or the sixteen-year-old Ferrante Gonzaga, portrayed in 1523.

The date, confirmed by the style of the clothes, reveals the extraordinary portraiture skills that Titian had already acquired by this time. A particularly successful device is constituted by the contrast between the area of shadow of the black gown and the dark background and the details picked out by the bright golden light that reveal the personality of the sitter: the delicate face, the uneasy gaze that avoids the viewer, the little details of aristocratic elegance (a gold chain with a pendant set with a sapphire and a pearl, a gold ring, and a pair of leather gloves). Finally, the simultaneously vigorous and gentle nature of the young man is revealed by the different pose of his hands, the right one clutching his gown, and the gloved left one hanging limply.

Annunciation

c. 1522
Oil on canvas, 166 × 266 cm
Venice, Scuola Grande
di San Rocco

The *Annunciation*, now next to the altar of the Sala del Capitolo in the Scuola Grande di San Rocco, was originally located opposite Tintoretto's *Visitation* beside the stairs of the confraternity building. Although Titian became a member of the Scuola di San Rocco in 1551, the work was not donated by the painter himself, but by the jurisconsult Melio Cortona, who left it to the confraternity in his will in 1555.

In the absence of any other documents or certain dates, there has been much debate regarding the chronological classification of the painting. The date generally proposed for the work is 1540, but Annalisa Perissa Torrini has noted that the sobriety and simplicity of the spatial organization of the scene still follows the Renaissance style, and the position, profile of the face, and shape of the long, slender hand make this Madonna stylistically similar to that painted by Titian before 1522 for the *Averoldi Polyptych* in Brescia.

The scene is pervaded by a sense of calmness and tranquillity and is set in a classical-style architectural space defined by perspective and which opens onto a luminous landscape. The skillfully rendered elements of the composition include the splendid details of the cloth on the balustrade, the sewing basket and the partridge, which are symbolic attributes of the Virgin and frequently depicted in fifteenth-century Annunciations, but they are also features capable of giving the scene a sense of realistic and everyday intimacy. The classic composure of the composition is broken only by the figure of the angel, captured in aerial movement and bathed in light.

Bacchus and Ariadne

1522–1523
Oil on canvas, 175 × 190 cm
London, National Gallery
Signed 'TICIANUS F.'

This work is part of a cycle of four paintings commissioned by Duke Alfonso I for his now lost private study in the Este castle, known as the 'Alabaster Chamber'. Although we do not know the exact location of the study or the arrangement of the paintings within it, it is certain that Alfonso based it on the *studiolo* of his sister, Isabella d'Este, in Mantua, decorating it with paintings that symbolized an escape from political life into the free world of Bacchus, Venus, and Cupid. The first scene of the decorative scheme was the *Feast of the Gods*, painted by Giovanni Bellini in 1514, which Titian subsequently modified, repainting the landscape and several figures in order to conform to his own works. Indeed, following the death of Fra Bartolomeo (1517) and Raphael (1520), who were to have painted two other Bacchanals for the chamber, Alfonso transferred both commissions to Titian, who painted the *Worship of Venus*, *The Andrians,* and the *Bacchus and Ariadne*.

Titian's paintings for Alfonso d'Este's *studiolo* allowed him the opportunity to tackle the theme of the relationship between Love and Music, which had already been the focus of several of his youthful works (including the *Pastoral Concert* in the Louvre and the *Three Ages of Man* in Edinburgh), though here for the first time he had to follow a program based on classical mythology devised by the court Humanists. The artist not only succeeded in translating into pictures the exact aspects of the ancient tales with which he had been provided, but also inserted complex allegorical meanings into this painting and its companion, *The Andrians*. While in this painting Titian has represented Bacchus with his exotic dancing retinue (the cart pulled by leopards, the maenads and satyrs, and Laocoön with the snakes) in reference to the Dionysian dimension as a liberation from the troubles of the world and history, he has added a moralizing reflection on the transience of human joy and the pastoral idyll in its companion, in the form of the figure of the old man on the top of the hill exhausted by drunkenness.

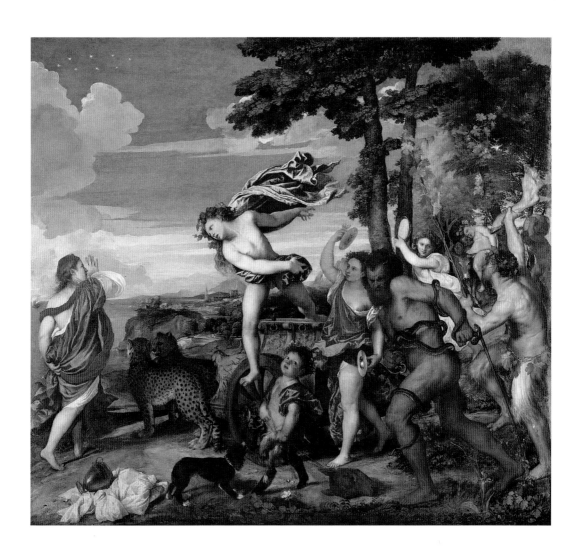

The Andrians (Bacchanalia)

1523–1524
Oil on canvas, 175 × 193 cm
Madrid, Museo Nacional
del Prado
Signed 'TICIANUS F.'

This canvas was painted to adorn the private study (the 'Alabaster Chamber') of the Duke of Ferrara, Alfonso I d'Este, along with the *Worship of Venus*, also in the Prado, and the *Bacchus and Ariadne*, in the National Gallery in London.

It was taken to Rome in 1598 by Cardinal Aldobrandini and to Spain in 1639, when it was presented to King Philip IV. As for the other paintings in the Ferrara cycle, Titian had to follow a precise iconographic program, in particular the passage from Philostratus' *Imagines*, which describes Dionysus sailing towards the island of Andros, where he is awaited by its inebriated inhabitants. The Dionysian episode is understood as an occasion to free oneself from the troubles of the world and history, which was exactly what Alfonso sought in the private dimension of his *studiolo*. During the revelry, the waters of the stream are turned into wine and the inhabitants of Andros give themselves up to the pleasures of drinking, dancing, pastoral music, and eroticism, personified by the satisfied nymph-bacchant sleeping on the right of the painting. The Dionysian theme is also echoed in the page of music lying on the ground in the center of the painting, which bears the words *Qui boit et ne reboit / Il ne scet que boit soit* ("He who drinks and does not drink again / Does not know what it is to drink"), a motto destined to be repeated according to a "circular canon, as infinite as inebriation".

Nonetheless, Titian does not fail to add a moralizing element to this exhortation to orgiastic abandon: indeed, an exhausted old man lies on the top of the hill in the background of the painting, symbolizing the transience of the pastoral idyll.

Tietze has identified a very interesting reference to Michelangelo in the central figure of the young Bacchant lying next to the girl raising a cup, which is taken from a cartoon made by Michelangelo for the *Battle of Cascina*, now in the Leicester collection.

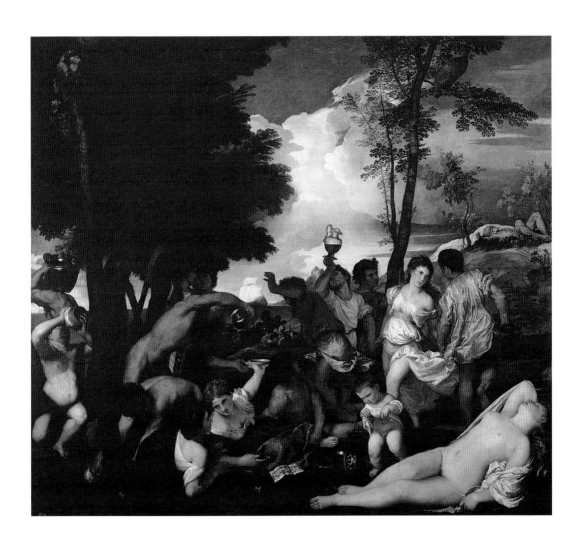

Portrait of Isabella d'Este

1534–1536
Oil on canvas, 102 × 64 cm
Vienna, Kunsthistorisches
Museum

At the time Titian painted this portrait of Isabella d'Este —the daughter of the Duke of Ferrara, Ercole I, and Leonora of Aragon, who had married the Marquis of Mantua, Francesco II Gonzaga in 1490— she was over sixty years old. However, as testified by the painter's correspondence, Titian was commissioned to paint a portrait from a canvas by Francesco Francia depicting her as a girl.

As in other portraits painted from earlier works (for example, those of Charles V, François I of France, and Julius II), Titian concentrated on the elements denoting the social status and personality of the subject. In this case he paid tribute to the keen collector of works of antique and contemporary art and the extraordinary champion of intellectual activities and culture who had made Mantua one of the most refined courts in Renaissance Italy. The marchesa was renowned for her exquisite taste, which also extended to her grooming and dress, to the extent that the noblewomen of the Italian courts would ask her if they could copy her garments, and the Queen of France even requested a mannequin entirely dressed in her clothes. She is shown here in a sumptuous turban (*balzo*) and a gown with sleeves adorned with elegant gold and silver trim. In addition to her intelligence and elegance, in this portrait Titian also celebrated the young Isabella's beauty, at a time when it had already faded, unlike the sardonic Pietro Aretino, who went as far as defining her as "dishonestly ugly" and "supremely dishonestly embellished," with her "ebony teeth" and "ivory eyelashes." The painting, which has been trimmed on both sides, passed from the Gonzaga collection in Mantua to that of Archduke Leopold Wilhelm, where in 1659 it was erroneously described as a portrait of the Queen of Cyprus, before being correctly identified by Luzio.

The Presentation of the Virgin in the Temple

1534–1538
Oil on canvas, 335 × 775 cm
Venice, Gallerie
dell'Accademia

The painting is still in its original setting, the Sala dell'Albergo della Scuola Grande di Santa Maria della Carità, in the same building that houses the Gallerie dell'Accademia. The cutout area in the lower part of the canvas, above the right door, is also original, while that over the left one dates to a later period, though it was already mentioned by Boschini in 1664. It is the only example of a large narrative canvas painted by Titian. This was a typical genre of Venetian painting, which was widely practiced in previous decades, especially by Giovanni Bellini and Vittore Carpaccio, but was rapidly becoming obsolete. The artist has renewed it in this work, creating a grandiose composition framed by Classical-style architecture, with numerous references, including Renaissance theatrical sets and reflections on the architecture and stage design of Sebastiano Serlio, and the buildings designed by Jacopo Sansovino, who arrived in Venice in 1527. Indeed, during the same period in which Titian was working on this painting, Sansovino was engaged in the great urban facelift given to Saint Mark's Square and the Piazzetta, in which an uninterrupted succession of Classical-style buildings was created from the Mint to the Clock Tower. This was the material translation of the ambitious project of *renovatio urbis* promoted by Doge Andrea Gritti, who had

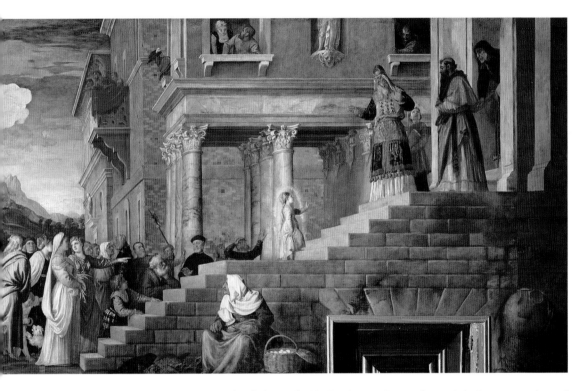

decided to make Venice the new Rome, the capital of a great empire and the heir of both the Rome of the East (Constantinople), which had been captured by the Turks in 1453, and the Rome of the Popes, sacked by Charles V's troops in 1527. The religious importance of the ceremony of the presentation of the Virgin-Child in the temple is completely entrusted to the imposing architectural setting, enriched by a dazzling color scheme. On the left are the members of the confraternity. Among these, Rifolfi identified Andrea de' Franceschini "in ducal attire" and Lazzaro Crasso, who are probably the two figures heading the group.

Portrait of Eleonora Gonzaga della Rovere

1536–1537
Oil on canvas, 114 × 103 cm
Florence, Galleria degli Uffizi

Titian painted the portrait of Eleonora Gonzaga, wife of Francesco Maria della Rovere, the duke of Urbino, during the autumn and winter 1536–1537, shortly before that of her husband. In January 1536 the duchess informed her ambassador in Venice of her wish to be painted by Titian, if he should be passing through Pesaro, home of the Urbino court. However, as Valcanover has shown, Titian did not paint Eleonora in Pesaro, but during her stay in Venice between September 1536 and the early months of the following year.

The artist was able to paint her portrait from life, resulting in a work whose meticulously rendered physical details reproduce the sitter's prestige in an exemplary manner: the profusion of jewellery; the marten fur, with gold head studded with pearls and rubies, held in her right hand; the heavy grey and black striped fabric of her gown adorned with golden bows, recalling the colors of the coat of arms of the Montefeltro family (whose duchy had been inherited by her husband, adopted in 1504 by his uncle Guidobaldo, who had no male descendants); the small dog, both a detail of intimate realism and a symbol of conjugal faithfulness; and lastly the interesting detail of the finely-chased clock crowned by a statuette on the table draped with green velvet that stands beneath the window overlooking the luminous background landscape. This is the first time that a clock appears in Titian's work (and he subsequently depicted it again in several portraits of men). It can be interpreted as a symbol of the fleeting nature of time and life or—as suggested by Panofsky—as an allusion to temperance, due to its regularity. It should also be remembered that the dukes of Urbino were keen clock collectors, and Titian acted as an intermediary for the couple on at least one occasion for the purchase of a timepiece made by a master clockmaker in Augsburg.

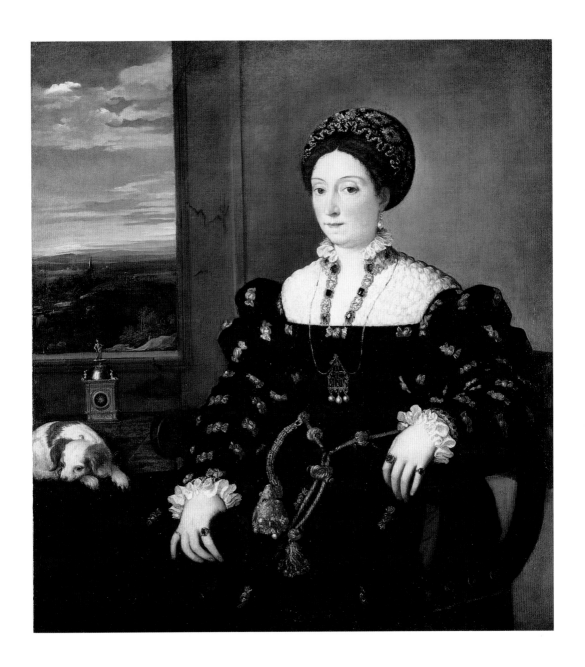

Portrait of Francesco Maria della Rovere

1536–1537
Oil on canvas, 114 × 103 cm
Florence, Galleria degli Uffizi

Francesco Maria della Rovere, duke of Urbino and captain-general of the Venetian Republic, commissioned this portrait of himself from Titian, together with that of his wife, Eleonora Gonzaga. The painter began work on it in the spring or summer of 1536, as testified by a letter written on July 17, 1536, by Francesco Maria to Gian Giacomo Leonardi, his ambassador in Venice. The letter informs us that Titian had borrowed one of the duke's suits of armor in order to depict it in the painting. However, work was delayed because Titian completed the portrait of Eleonora first, who was in Venice between September 1536 and the early months of the following year. During the same period Francesco Maria was continuously engaged in military campaigns and inspections of the fortresses and troops that defended the Venetian Republic. His portrait was thus probably only painted from life for the face, while the armour, worn by a model or mannequin, was painted at the artist's leisure.

The proud, determined figure of the duke is surrounded by a series of elements that sum up his career as a military leader: the gleaming suit of armour, praised by Aretino in a letter to the poetess Veronica Gambara in 1537, the sword and the baton of command, held in his right hand, the symbol of generalship received from the Venetian Republic, and the objects resting on the red velvet surface in the background. The item on the far right is the insignia of generalship awarded to him by Florence, the one on the left refers to the same office conferred on him by the Church, while the oak branch in the center with the motto *se sibi* identifies the duke as a captain of fortune. Finally, on the right, Titian has depicted a splendid helmet topped by a dragon that alludes to the leader's connections with the house of Aragon. However, this brilliant military career was destined to end with the Duke's death just a few months after the arrival of the portrait in Pesaro.

Venus of Urbino

1538
Oil on canvas, 119 × 165 cm
Florence, Galleria degli Uffizi

This painting was commissioned from Titian in 1538 by Guidobaldo della Rovere, duke of Camerino and future duke of Urbino. He was the son of Francesco Maria and Eleonora Gonzaga, for whom the artist had painted a pair of portraits also in the Uffizi just a few months earlier. On several occasions during 1538 Guidobaldo urged his agent in Venice to purchase the *donna ignuda* for him, for which he repeatedly requested the necessary money from his reluctant mother.

The splendid female nude—for which the painter used the same model who had sat for the *Girl in a Fur* in Vienna and the so-called *La Bella* in Palazzo Pitti—reveals how Titian had departed from the famous model of the *Sleeping Venus* painted by Giorgione in 1507 and partially repainted by Titian himself in 1510. Here Giorgione's ideal and serenely contemplated beauty has been replaced with a highly sensual image: the goddess of love is no longer sleeping in a peaceful natural setting, but lies on an unmade bed, her hair around her shoulders, staring straight at the observer with a seductive gaze. The traditional attributes of Venus—the roses in her right hand and the vase of myrtle on the windowsill—are flanked by realistic details that create an atmosphere of coy intimacy, such as the little dog curled up on the bed and the maids taking rich gowns from the wedding chest, transforming the mythological deity into an "earthly Venus at the palace". The painting emphasizes the importance of the erotic dimension within marriage and probably had a very specific purpose: Guidobaldo, who had so keenly wanted to possess the painting, had married Giulia Varano da Camerino for political reasons in 1534 when she was just ten years old. Titian's painting, in a skilful and culturally prestigious allegorical disguise, may have been intended to persuade his now adolescent wife to consummate their union.

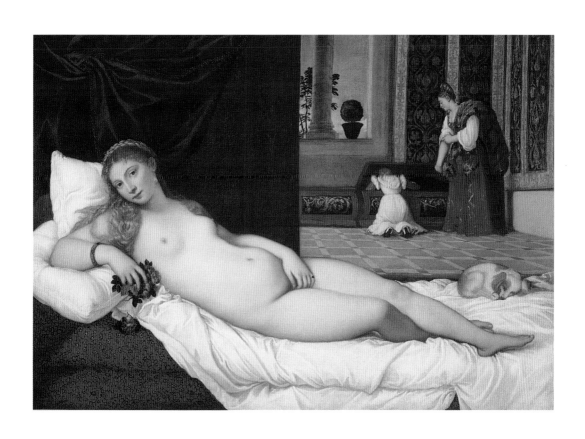

Portrait of Cardinal Pietro Bembo

1539
Oil on canvas, 94.5 × 76.5 cm
Washington, National Gallery
of Art

This painting was included in the Roman collection of the Barberini family in the seventeenth century and depicts the famous Humanist Pietro Bembo (1470–1574). He was a friend of Titian, who painted at least two portraits of him. Bembo belonged to an aristocratic Venetian family and had already acquired a reputation as a man of letters by 1505, when he wrote his famous dialogues on platonic love entitled *Gli Asolani*, which he dedicated to Lucrezia Borgia. After having spent six years at the court of the duke of Urbino, he became secretary to Pope Leo X. A collector of paintings and archaeological pieces, he played a leading role in the 'language question'; in 1530 he was appointed librarian of Saint Mark's and nine years later was made a cardinal. This portrait, now in Washington, is mentioned by Bembo himself in a letter dated May 1540. It was probably painted between March 1539, the date of Pietro's promotion to cardinal, and October the same year, when he left Venice to live in Rome.

It is thus an official portrait celebrating Pietro Bembo's recent acquisition of the cardinal's hat. The figure of the prelate stands out against an undefined dark background, wearing the scarlet gown and cap denoting his high rank. The stern face with high forehead, narrow aquiline nose, hollow cheeks and tight-lipped mouth is energetically turned in the opposite direction from the slightly twisted torso, and has been idealized by the painter with the aim of emphasizing the cardinal's acumen and sharp intellect. The pose of the figure, with the right arm raised in a rhetorical gesture, also identifies Bembo as an intellectual and Humanist, presented as if he were intent on expounding his literary and linguistic doctrines. The position of his arm and outline of his hand, which follows the hemline of his cloak, give the painting the plastic vigor of a sculpted bust.

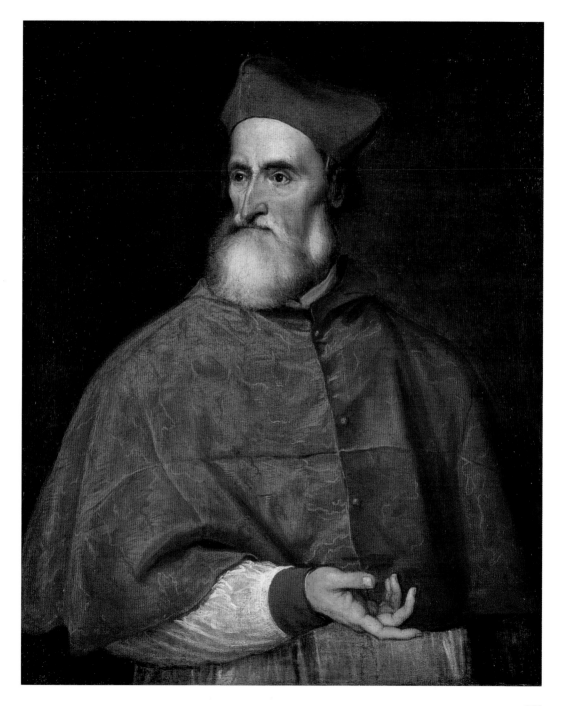

109

Saint John the Baptist

c. 1540
Oil on canvas, 201 × 134 cm
Venice, Gallerie
dell'Accademia
Signed 'TICIANUS'

This painting, which originally adorned the altar of San Giovanni in the Venetian church of Santa Maria Maggiore, was transferred to the Gallerie dell'Accademia in 1807 when the church was closed. It depicts the statuesque figure of Saint John, standing and seminude, with his usual attribute of the lamb, at the center of a luminous mountain landscape crossed by a clear stream of water, which refers to the mission of the Baptist. The composition of the painting, which critics date to the period between the 1530s and 1557, the year in which Dolce described it in *Dialogo della Pittura*, can be plausibly placed around 1540, the period of Titian's closest encounters with the artistic style of the Mannerists of Tuscany and Rome. The sculptural quality of the saint's body, the anatomic description, and the eloquent pose bear witness to the painter's study of classical statuary and the art of Michelangelo and his followers. These stylistic elements of Saint John, which were praised by Dolce and Vasari, have been labeled as academicism and condemned by many modern critics: Longhi described the work as "oppressive" (1946) and Pallucchini (1969) drew attention to the fact that "there is something stagnant in the formulation of that obviously posed muscular image."

Actually, the painting represents an exemplary and highly successful synthesis of programmatic academicism, as revealed in the design and modeling of the sculpturesque figure of the saint and the innovative and very rich arrangement of colors. The saturated impastos, bright tones, and rich luminosity of the evocative landscape depicted in the background, enhanced by the restoration performed in 1981, reveal how Titian intended this painting as his contribution to the debate on art and aesthetics that was raging in Venice during the period, providing a tangible demonstration of the possibility of merging Tuscan *disegno* with Venetian *colorito*.

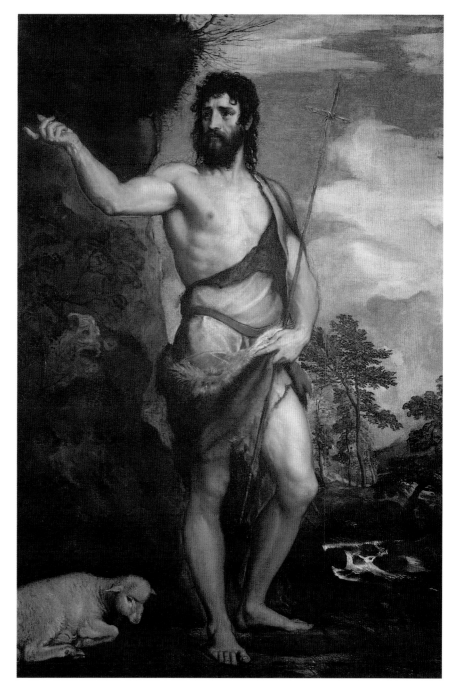

Alfonso d'Avalos Addressing his Troops

1540–1541
Oil on canvas, 223 × 165 cm
Madrid, Museo Nacional
del Prado

The painting shows Alfonso d'Avalos, Marquis of Vasto and Pescara, addressing his troops beside his son, Ferrante, probably during the war against the Ottoman army of Suleiman II, which commenced in 1530. The work was commissioned by the Marquis at the beginning of 1539 and was begun the following year (as testified by a letter written by the painter's friend Pietro Aretino) and delivered to the clients in Milan in August of 1541. It subsequently probably passed into the Gonzaga collection in Mantua, and then that of Charles I of England, before being documented among the assets of the king of Spain in 1666. The scene depicted is dominated by the figure of the armor-clad leader holding the baton of command in his left hand and with his right hand raised in the *adlocutio* gesture, typical of Roman consuls and emperors. It appears that Titian drew his inspiration for this figure from the sculpture of *Trajan Addressing the Troops* on the Arch of Constantine and from Giulio Romano's painting of *Constantine Addressing the Troops* that adorns the Hall of Constantine in the papal apartments of the Vatican Palace. These direct references to antique sculpture and the works of the central Italian mannerist painters clearly reveal Titian's sensitivity to the stimuli that he received during the early 1540s from the central Italian artists who flocked to Venice and with whom he had the chance to compare himself (they included Giuseppe Porta, Francesco Salviati and Giorgio Vasari). Titian's knowledge of these painters and the works produced in northern Italy by Pordenone, Giulio Romano, Sebastiano Serlio, and Jacopo Sansovino, plus his familiarity with Classical sculpture in the Venetian collections and awareness of the innovations of Raphael and Michelangelo through engravings, contributed to the expressive enrichment typical of his works in this period, and was always skilfully combined with that sensitivity to color peculiar to the Venetian tradition.

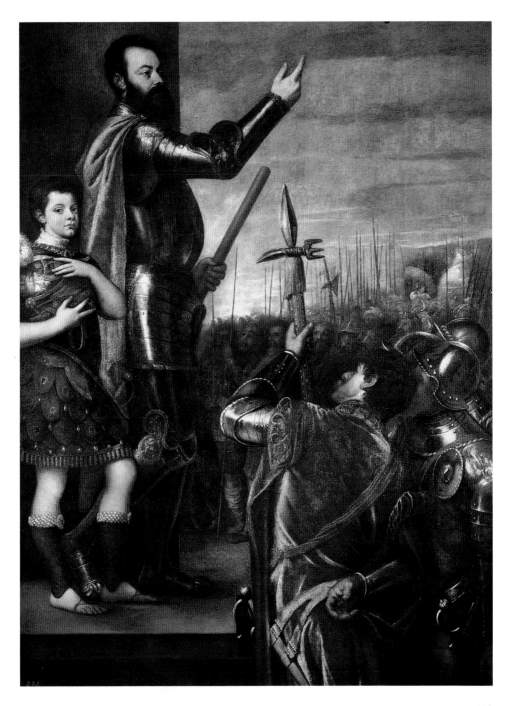

Ranuccio Farnese

1542
Oil on canvas, 89.7 × 73.6 cm
Washington, National Gallery of Art
Signed 'TITIANUS/F.'

In 1542 Titian painted the portrait of the twelve-year-old Ranuccio Farnese, son of Pier Luigi, commander of the papal army and grandson of Pope Paul III. During this period the boy was attending a course of Classical studies in Padua, accompanied by his tutors —the humanist Gianfrancesco Leoni and Bishop Andrea Cornaro. In the course of his stay in Veneto, he had been appointed prior of San Giovanni dei Furlani, an important religious property belonging to the Knights of Malta. The portrait was commissioned from Titian by Bishop Cornaro as a gift for Ranuccio's mother, Girolama Orsini, although the artist had already offered his services as a painter to the illustrious Farnese family through Pietro Aretino two years earlier. This was the first of a long series of works painted for this noble dynasty, which was immediately to become Titian's most important patron after the Habsburg family. The painting passed from the Farnese collection in Rome to Parma and then Naples, reappearing in England at the end of the nineteenth century, before entering the Kress collection in Washington in 1949. It is one of Titian's masterpieces of portraiture and uses a very limited palette in order to concentrate all the attention on the psychological description of the subject: the dark tones of the background and the cloak adorned with the silvery white cross of the Knights of Malta, the golden hues of the boy's flesh and the rosy shades of his sumptuous gown. Here the artist has probed his subject's personality with surprising insight and sensibility, playing on the contrast between the boy's slender body, immature features and timid gaze and the heavy cloak resting on his shoulder that symbolized the power and dignity of his rank. The almost affectionate attention to the boy betrayed by the painting, and the undeniably skilled use of technique and color probably played a fundamental role in winning Titian the favor of the powerful family with which he had long sought to ingratiate himself.

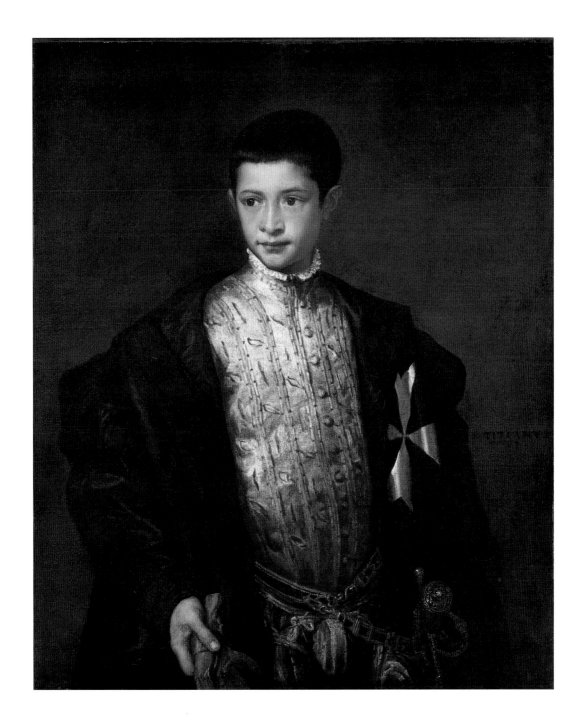

The Vendramin Family

1543–1547
Oil on canvas, 206 × 301 cm
London, National Gallery

This splendid family group was probably commissioned from Titian by the Venetian senator Gabriele Vendramin, who appears in the center of the scene, with his hand resting on the altar.

The nine members of the Vendramin family, divided into groups of three, are shown venerating the reliquary of the True Cross belonging to the Scuola Grande di San Giovanni Evangelista on the altar.

The relic was brought to Venice from the Holy Land in 1369 by Philippe de Mezières, who presented it to the grand guardian of the Scuola, Andrea Vendramin, an ancestor of the figures depicted in the painting. The focus of the composition is the figure of the elderly Gabriele, shown kneeling beside the altar, looking out of the painting. He is flanked by his brother, Andrea, who is depicted climbing the first step, eyes fixed on the reliquary. His detached attitude, removed from worldly reality and addressed exclusively at the adoration of the relic—unlike that of the other figures—suggests that Andrea was portrayed after his death, which occurred in 1547. His son Lunardo, who is shown behind him, also portrayed in profile, was also to die the same year. The two groups of younger men include Lunardo's sons—Luca, Francesco, and Bartolo—on the left, and those of Andrea—Giovanni, Filippo, and Federico—on the right.

Titian has arranged the members of the Vendramin family along two slightly diagonal lines, against the open sky; the low viewpoint heightens the sculptural effect of the figures. In comparison with other paintings of the same period, in this work dramatic emphasis is played down in favor of the intensity of the religious sentiment of the older figures, in contrast with the carefree attitudes of the younger members of the family.

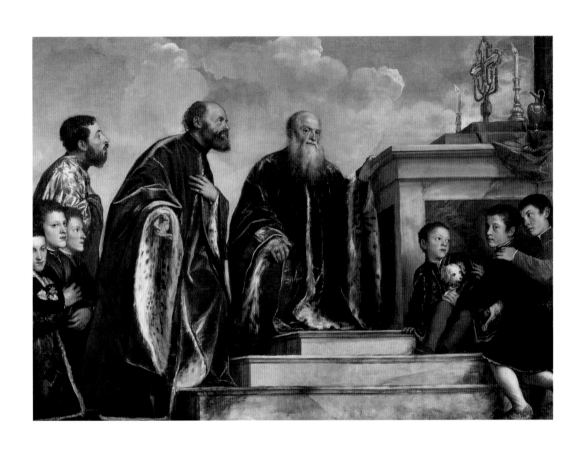

Danaë

c. 1545
Oil on canvas, 120 × 172 cm
Naples, Museo e Gallerie
Nazionali di Capodimonte

Titian probably commenced this painting in Venice in 1544 and completed it during his Roman sojourn in 1545–1546. It was commissioned by Cardinal Alessandro Farnese, the grandson of Pope Paul III. The painting remained in the Italian capital until 1649, but was subsequently moved numerous times (to Parma, Naples, Palermo, and back to Naples), seized by Hermann Goering during World War II, recovered in Austria after the war, and returned to the Italian State in 1947.

The mythological subject of the painting is clearly erotic in nature: Danaë, imprisoned in a bronze chamber by her father King Acrisius of Argos, was seduced by Jupiter in the form of a shower of golden rain. Titian has depicted the worldly metamorphosis of the father of the gods applying the color to the canvas with soft, undefined brushstrokes, using a technique that did not permit preparatory drawing.

The absence in Titian's work of *disegno* and chiaroscuro, confirmed by recent x-rays, had already been noted by Michelangelo, who—according to Vasari—commented on the *Danaë* that Titian had just finished painting at Belvedere, praising the color and the manner, but lamenting the absence of drawing.

Indeed, this work well illustrates the development of Titian's language following his encounter with central Italian mannerism that distinguished his paintings of the early 1540s, such as the *Saint John the Baptist* housed in the Accademia, or the *Crowning with Thorns* in the Louvre. However, by the time he painted the *Danaë*, his attention to the sculptural effects recognizable in these earlier works had been supplanted by an original style, characterized by great freedom in terms of technique and color, of which he wished to give a clear demonstration in Michelangelo's Rome.

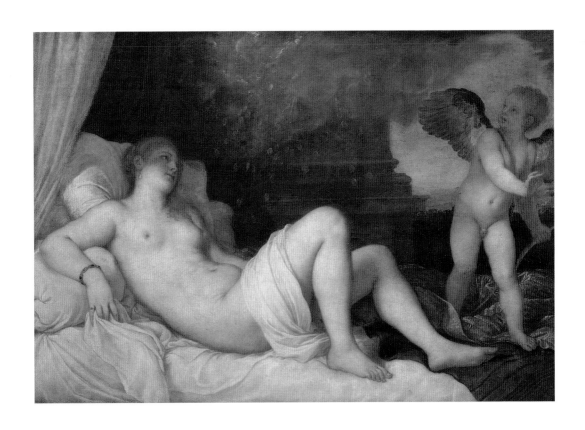

Portrait of Pietro Aretino

1545
Oil on canvas, 96.7 × 76.6 cm
Florence, Galleria Palatina
di Palazzo Pitti

This is one of Titian's many portraits of the Tuscan writer and controversialist Pietro Aretino, who arrived in Venice following the Sack of Rome in 1527 and established a lasting personal and professional relationship with the artist. The painting was sent as a gift to the Grand Duke of Florence and Tuscany, Cosimo I de' Medici, in October 1545 by Aretino himself, who accompanied it with a letter praising the work, "which breathes, whose pulse throbs and spirit moves in the way I do in life." The portrait is one of Titian's masterpieces, in which the artist has perceptively managed to capture the physical and spiritual characteristics of his model. The figure of Aretino stands out with sculptural monumentality against a dark background. His solid body is covered with a sumptuous red gown and adorned with the chain presented to him by the king of France, François I, in a pose that exudes repressed energy. Above the wide shoulders, Aretino's head is turned to the left in an energetic and almost angry jerk, while his serious and frowning gaze avoids the viewer and stares to the right. Titian has represented the cynical and violent nature of his friend—as he himself acknowledged in the letter quoted above—in this dynamic and animated likeness, which is diametrically opposed to the cold and formal stylistic refinement typical of the contemporary portraits of the central Italian mannerists.

Color is the principal means of expression in this portrait and is used with great intensity, applied with large, quick brushstrokes, which are rough and 'unfinished' in some areas. The value of this technical experiment, which paved the way for Titian's late works, was not comprehended by the painter's contemporaries, starting with Aretino himself, who complained in a letter to his friend of the fact that his portrait—that he had elsewhere referred to as a "terrible wonder"—was "rough-hewn rather than polished."

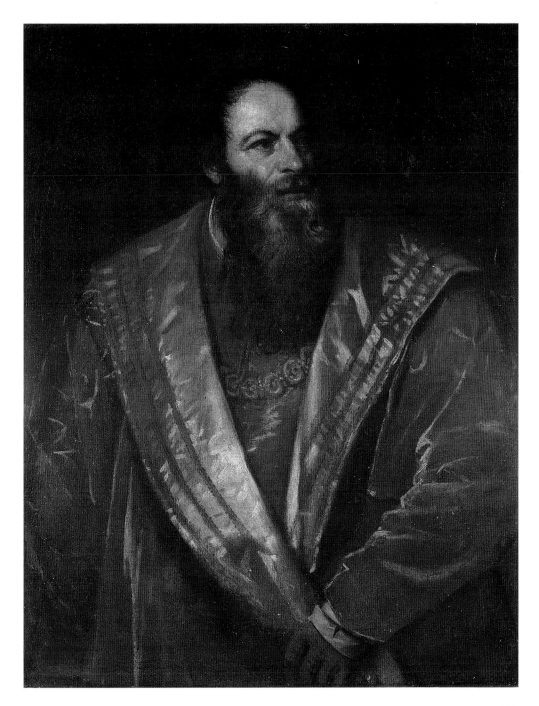

Doge Andrea Gritti

1545–1548
Oil on canvas,
133.6 × 103.2 cm
Washington, National Gallery
of Art
Signed 'TITIANUS E. F.'

Titian painted this portrait of Andrea Gritti, the great military leader and doge of Venice from 1523 to 1538, several years after the man's death, possibly commissioned by his family. He had already depicted Gritti in two earlier paintings that were both hung in the halls of the Doges' Palace: the official portrait for the Sala del Maggior Consiglio and the votive painting for the Sala del Collegio, both of which were destroyed in the fire that damaged in the palace in 1577. Titian had a close relationship with the ambitious doge, who was the spirit behind the *Renovatio urbis Venetiarum*. Gritti gave him important public commissions, including the frescoes for a chapel in the Doges' Palace (also destroyed) and the *Saint Christopher* in the doge's apartments. In 1527, the year of the Sack of Rome, Andrea Gritti invited Jacopo Sansovino and Pietro Aretino to Venice. The two men established such a close and influential relationship with Titian that they formed a kind of triumvirate that monopolized all the cultural ventures in the city.

This explains why, years later, the artist depicted Gritti as an extremely heroic and forceful figure in this portrait: the doge, with the golden cloak and conical hat symbolizing his office, stands imposingly against the dark background in a severe and dynamic pose. In this work Titian has broken the immobility of state portraits in favor of an "action portrait" (David Alan Brown) comparable to his dramatic religious paintings of the 1540s. The portrait also resembles the paintings of these years in its rapid, perfunctory and almost rough application of color, which in this period was limited to reds, browns, white, and gold. While Gritti's lineaments have been portrayed sufficiently faithfully to make him easily recognizable, the figure has been idealized with the aim of giving the doge leonine features, such as the gesture of his hand that recalls the pose of the lion of Saint Mark, the symbol of Venice.

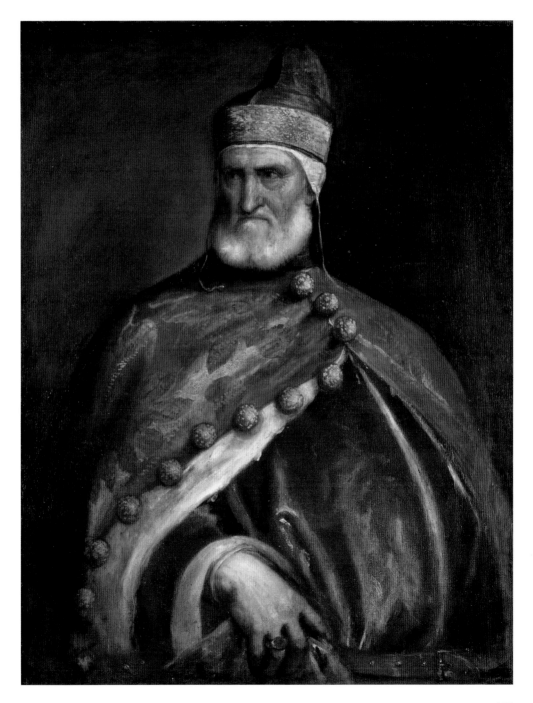

123

Pentecost

c. 1546
Oil on canvas,
570 × 260 cm
Venice, Santa Maria della
Salute

Titian painted this work, conserved in the Venetian church of Santa Maria della Salute since 1626, for the high altar of the Church of Santo Spirito in Isola. As documented by a series of deeds in the Archivio Patriarcale di Venezia, Titian had painted a first version of the altarpiece in 1541, but this deteriorated rapidly, causing the church to suspend payment to the artist. A lawsuit in the ecclesiastical court ensued (during which Titian requested the support of Cardinal Alessandro Farnese), which ended in 1545 with the repainting of the work. However, it has been suggested that the dissatisfaction with the first version of the painting was not so much attributable to technical problems as to the questions of doctrine raised by the innovative image of fire adopted by the artist to represent God the Father, which is mentioned in contemporary descriptions. The second version of the work was painted during Titian's Roman sojourn in 1545–1546, as revealed by the architectural framing of the scene, which, reproduces the structures used by Bramante for the building of Saint Peter's, which although incomplete, was nevertheless an imposing sight. The reference to Saint Peter's may also have served the purpose of reasserting the absolute supremacy of the Catholic Church in the world, for the Pentecost is one of its central concepts. A barrel vault is depicted in the upper part of the altarpiece, surmounting a semicircular window that is undoubtedly derived from Roman architecture. Below, the artist has painted the figures of the Virgin, the apostles and the disciples present at the moment of the descent of the Holy Ghost in a pyramidal composition. The apex is formed by the dove, the symbol of the Holy Ghost, which radiates light terminating in the flames resting on the heads of each of the onlookers. The experimentation with light is thus combined with the architectural and pictorial influences of Titian's recent stay in Rome, which were nonetheless soon destined to be reabsorbed in his works of the subsequent years.

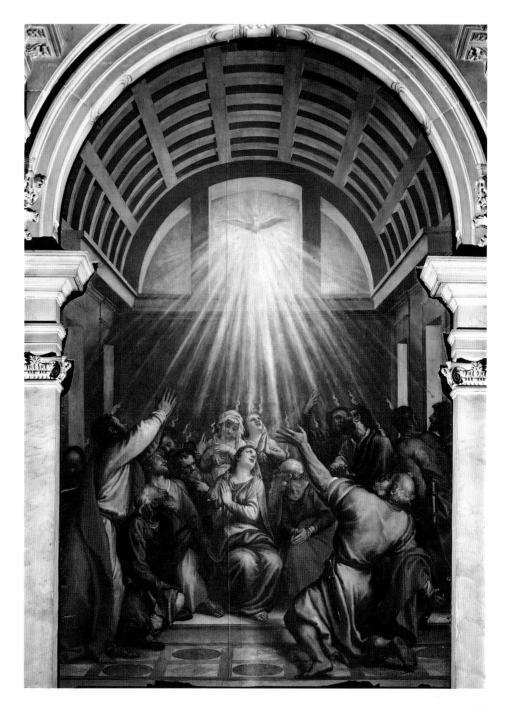

Pope Paul III with his Nephews Alessandro and Ottavio Farnese

1546
Oil on canvas, 210 × 174 cm
Naples, Museo e Gallerie
Nazionali di Capodimonte

This painting, commissioned by the Farnese family, as documented by Vasari, demonstrates the influence exerted on Titian by Raphael's famous portrait of *Pope Leo X with Two Cardinals* (Giulio de' Medici and Luigi de' Rossi), which inspired the underpainting even more directly, as x-ray examination has revealed. Titian also followed the same models in the definitive work, where he chose to represent the pope together with two nephews, breaking away from the rigid model of the 'state portrait' in favor of an almost narrative 'action portrait'.

Although the work was painted during the artist's Roman sojourn, it displays Titian's complete independence from the central Italian mannerist style, whose characteristic formal and stylistic elegance he has replaced with his own extraordinary and subtle capacity for psychological analysis. His rapid brushstrokes have captured the prudent and suspicious character of the elderly pope in the center of the painting without idealizing him. Although depicted bony and curved, Paul III is clearly not lacking in either energy or shrewdness, as revealed by his left hand that clutches the arm of his chair. The artist has shown him gazing piercingly at his nephew Ottavio, as he ceremoniously bows to him, while Cardinal Alessandro, on the right, casts a melancholy look at the viewer. In this work Titian has managed to describe the character of each of the three members of the Farnese family and capture the atmosphere of court intrigue with such unprecedented and unadorned truth that the three subjects preferred other more 'official', and less psychologically revealing, individual portraits to this family group, such as that of Alessandro Farnese, housed in the same gallery. The extraordinary real life quality of this painting is heightened by the completely free and lavish use of thick, warm color, applied with quick, rough brushstrokes, which is capable of counterfeiting reality and was diametrically opposed to the smooth, almost metallic colors of contemporary Roman artists.

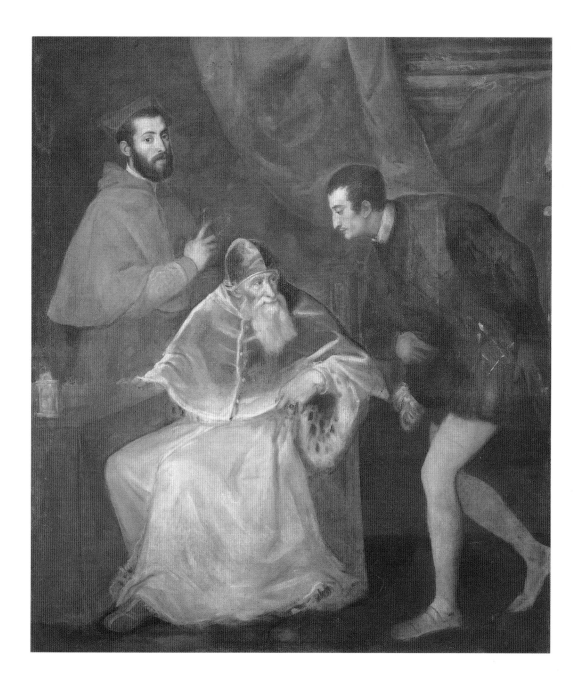

Charles V on Horseback

1548
Oil on canvas, 322 × 279 cm
Madrid, Museo Nacional
del Prado

The large canvas depicting Emperor Charles V on horseback was painted by Titian in 1548 in Augsburg, where the artist had arrived at the beginning of the year in the company of his son Orazio and Lamberto Sustris, and immediately commenced a series of portraits of the leading figures of contemporary European history. Indeed, Charles V had called a diet in the Swabian city to meet the princes who had embraced the Lutheran Reform, at a time that he considered particularly favorable for the Catholic cause, for he had defeated the Protestant armies of the Smalcald League the previous year (January 18) at Mühlberg, on the banks of the Elba.

Titian has depicted the emperor at this historic moment in the great equestrian portrait: he is shown alone against the landscape illuminated with the diffused light of sunset, scanning the horizon with the proud expression of the *miles christianus*, although his face shows traces of tension and weariness. The artist's great psychological insight has even permeated a thoroughly official work such as this, breaking the tradition according to which state portraits were required only to provide a faithful physical description and celebrate the political and social role of the subject. This portrait of Charles V on the battlefield at Mühlberg celebrates the power and status of the emperor (inaugurating the genre of the official equestrian portrait that was to prove highly popular at the Spanish court during the following century, particularly with Velázquez), but also combined this exaltation with action, integrating the personality with the sensitivity and innermost being of the subject.

The painting arrived in Spain as part of the legacy of Queen Mary of Hungary, was initially housed in the El Pardo royal hunting lodge, and subsequently at the Alcázar, where it was damaged by fire in 1734, before being transferred to the Prado.

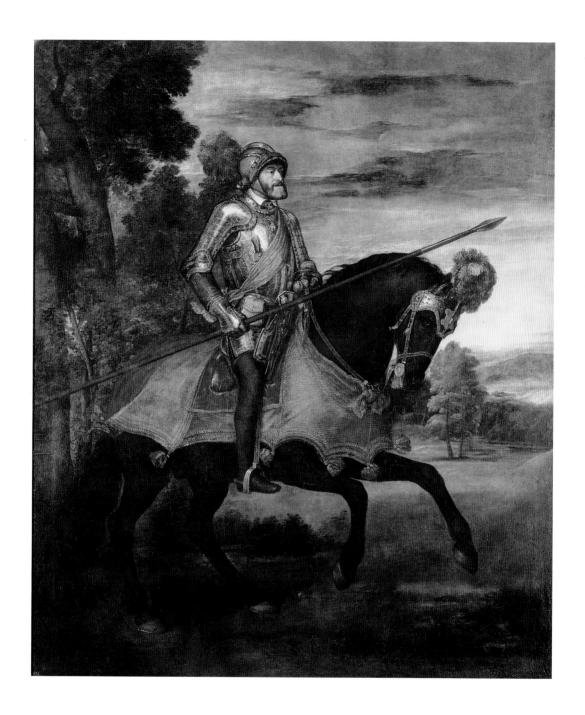

129

The Martyrdom of Saint Lawrence

1548–1557
Oil on canvas, 493 × 277 cm
Venice, church of the Jesuits
Signed 'TITIANUS VECELLIUS
AEQUES F' (spurious,
reproducing the original one)

The *Martyrdom of Saint Lawrence*, destined for an altar in the Venetian church of the Crociferi (transferred to the Jesuits in 1657), was commissioned from Titian by Lorenzo Massolo, probably between 1546 and 1547, soon after the artist's return from Rome. It was largely painted in 1548, though it still hadn't been entirely completed by the time of the patron's death in 1557. The scene represents the martyrdom of Saint Lawrence (the client's namesake) on the gridiron, described in a text by Prudentius, who identified the passion of the saint as the moment of the definitive transition from paganism to Christianity.

The dramatic scene takes place in a nightscape illuminated by glowing light from various sources: the flames blazing beneath the gridiron, the burning torches, and the supernatural flash rending the oppressive cloudy sky. The setting features numerous references to Classical architecture, which were fresh in the artist's mind following his return from Rome. These include the buildings and the colonnades of the temple on the right and, on the left, the large altar surmounted by the statue of a pagan idol, identified by Panofsky as Vesta holding a statuette of Victory, which, according to Sandro Sponza, may have been an allusion to the virtues of Massolo's wife, Elisabetta Querini. The figures in the scene of the martyrdom depicted in the lower part of the painting are also innovative reinterpretations of ancient models (including the *Dying Galata* in the Grimani collection in Venice, used for the body of the martyr), but also of the 'modern' inventions of Michelangelo and Raphael. However, here both the powerful human figures and the Classical perspective scenery are expressively animated, almost to the point of deformation and hallucination, by the dramatic use of light, which creates sharp and violent contrasts. This daring experimentation with light was to become a favorite subject for reflection and the starting point for the developments achieved by Paolo Veronese, Jacopo Bassano, El Greco and, above all, Jacopo Tintoretto.

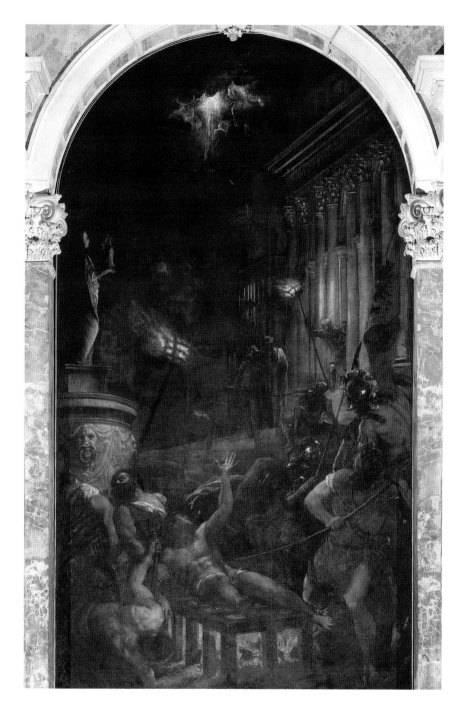

131

Saint John the Almsgiver

c. 1550
Oil on canvas, 229 × 156 cm
Venice, San Giovanni
Elemosinario

The altarpiece for the Venetian Church of San Giovanni Elemosinario, traditionally dated to the early 1530s, according to Vasari and Ridolfi, is actually likely to have been painted by Titian around 1550, following the period in which the artist renewed his expressive technique after his encounter with the work of the central Italian mannerists, which culminated in his Roman sojourn in 1545–1546. The complex composition of the scene is undoubtedly mannerist in style, and is dominated by the figure of Saint John the Almsgiver, patriarch of Alexandria, seated diagonally with a large book open in his left hand and his right hand reaching out to offer alms to a pauper. The three figures of the saint, the beggar and the young man on the right holding the processional cross are connected by their reciprocal gestures and their profiles, which follow diagonal lines. The vigorous figure of the beggar, whose 'dignity and power' were noted by Longhi in 1946, is seated on the steps in a pose charged with restrained energy that recalls Michelangelo's twisted bodies. However, here the sculptural tension is dispersed in the richness of the colors shrouded in a thick atmospheric veil; the space in which the figures are arranged opens up behind them into a luminous deep blue sky dappled with clouds. Effective contrasts of light and shade are created by the quick, broad, and freely overlapping brushstrokes. The light strikes the central figure of the saint, dominated by the purple and brown shades of his cloak that contrast with the iridescent silvery white of his surplice, while the two side figures, immersed in semi-darkness, are rendered with soft and simplified dark brown and murky green shades (Valcanover). The dulling and simplification of the tones, the approximate, blurred application of color, and the quest for dramatic expressiveness reflect the uneasiness that started to animate Titian's work from this period.

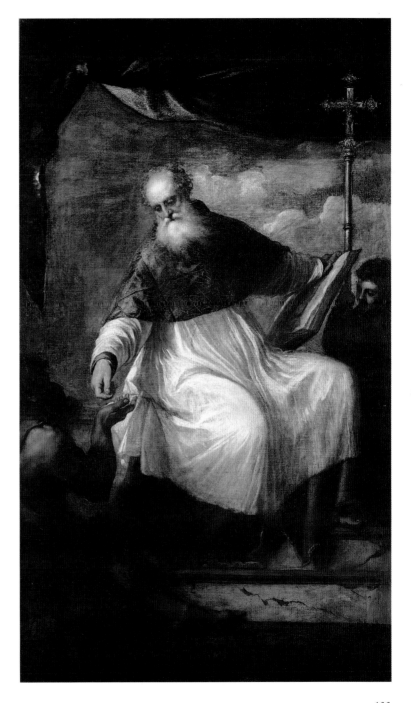

133

Venus with an Organist and a Dog

1550–1551
Oil on canvas, 136 × 220 cm
Madrid, Museo Nacional
del Prado

This painting depicts a clearly erotic subject —Venus lying on a bed—which represented a constant source of interest for Titian, as demonstrated by his *Venus of Urbino* painted in 1538. Unlike the traditional iconography of Venus, in this work (as in the other two versions—one in the Prado, in which the dog is replaced by a cupid, and the other in Berlin, which instead features both figures) Titian has added the figure of an organ player, fully dressed and carrying a sword, whose head is turned to gaze longingly at the glowing body of the goddess. The figure of Venus is directly illuminated by the light and emphasized by the contrast between the goddess's fair skin and the red velvet coverlet on the bed, which is echoed by the pink drape that frames the upper part of the scene. The sensuality of the image is reinforced by the symbolic elements that appear in the luxuriant Renaissance garden depicted in the background: young bucks locking antlers, a couple of lovers on the left, and a peacock perching on a fountain surmounted by the statue of a satyr on the right. The scene is pervaded by a sense of calmness and tranquillity disturbed only by the playful instinct of the little dog that Venus strokes affectionately.

Critics date this work to the early 1550s and have ascertained the hand of the artist's workshop in its execution. However, the other version housed in the Prado is considered of higher quality and was painted by Titian in 1548 for Philip II, whose features have been identified in the face of the organist (Gentili).

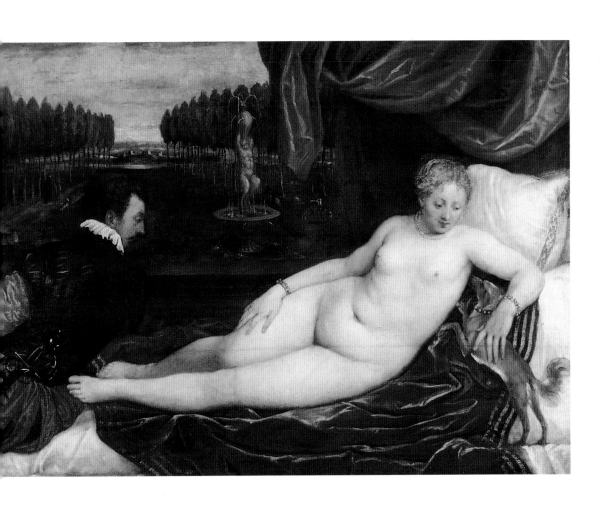

Venus and Adonis

1553–1554
Oil on canvas, 136 × 220 cm
Madrid, Museo Nacional
del Prado

This work was the first of the many paintings that Titian dedicated to the mythological theme of the love between Venus and Adonis, which he interpreted in various versions (the most famous of which include those in the Galleria Nazionale in Rome and the Metropolitan Museum in New York). In 1554 the artist sent the canvas to King Philip II of Spain, who was his main client from this time until Titian's death in 1576. Here, as in the other mythological works painted during his final years, Titian has interpreted the ancient myths with an approach completely different from the confident optimism that characterized his early representations of the same subject. The exuberant celebration of the joyful vitality of the Classical world, narrated in the festive and brightly colored scenes of the 1520s and 1530s (in particular, the works for the Duke of Este's Alabaster Chamber) has been replaced by a melancholy, even tragic meditation on the violence and cruelty of the ancient tales. Indeed, the painting housed in the Prado depicts the culmination of a tragic event: the abandonment of Venus by her lover Adonis, impatient to go hunting, which presaged his slaying by a wild boar.

As in other 'poems' painted for Philip during the following years (*Diana and Actaeon* and *Diana and Callisto*), Titian has concentrated on the theme of the hunt, a metaphor for the perpetually wandering human life subject to the whims of chance and the cruelty of the gods. The tragic dimension of the scene is emphasized by the contrast with the luminous and idyllic landscape in which it is set. The pose of the splendid nude figure of Venus was probably inspired by a famous series of ancient reliefs depicting Cupid and Psyche (known during the Renaissance as the 'Bed of Polyclitus'), which Titian may have seen during his Roman sojourn in 1545–1546.

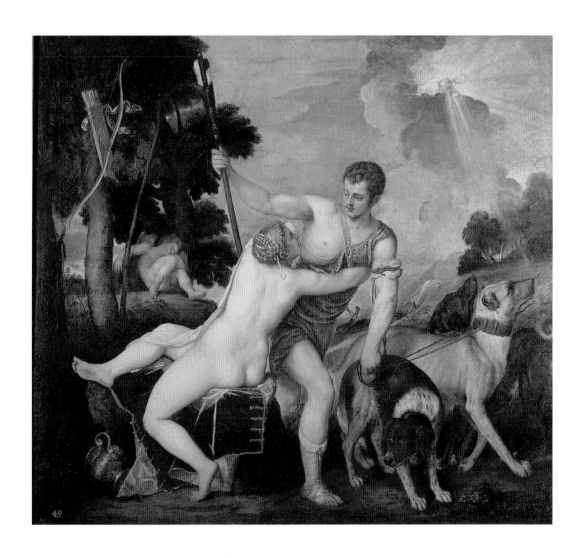

Venus with a Mirror

c. 1555
Oil on canvas,
124.5 × 104.1 cm
Washington, National Gallery
of Art

The painting shows a semi-nude Venus sitting on a bed as she admires her reflection in a mirror held by a cupid, while another cupid raises a garland of flowers. This is the only version of the many works in which the artist represented this subject (introducing several variations) that was undoubtedly painted by Titian himself. The canvas was still in the artist's studio when he died in 1576; he probably wished to keep it for himself as he was particularly satisfied with it and intended to use it as a model for successive copies. It was sold in 1581 by Pomponio Vecellio, the artist's son, to Cristoforo Barbarigo and sold in turn by his heirs to Czar Nicholas I in 1850. In 1931 the collector Andrew Mellon purchased the painting from the Hermitage, and donated it to the National Gallery of Art in Washington six years later.

Venus is depicted with one hand on her breast and the other in her lap, in a demure pose reminiscent of that of the famous Roman statue of the goddess (*Venus pudica*) that belonged to the Medici family and is now housed in the Uffizi. Titian may have seen the sculpture or a copy of it during his Roman sojourn in 1545–1546, but although inspired by an antique model, he created a warmly sensuous image with the skilled use of light and exploitation of the potential offered by the medium of oil paint. Recent x-rays of the work have revealed that Titian had originally intended to depict Venus decorously dressed in a white blouse, and also that the artist reused a canvas on which he had previously painted two three-quarter length figures of a man and a woman, turning it up the other way. When repainting the canvas with Venus and her mirror, the artist left the cloak of the male figure visible, skilfully transforming it into the splendid pattern of the scarlet velvet drape that swathes the lower part of the goddess's body.

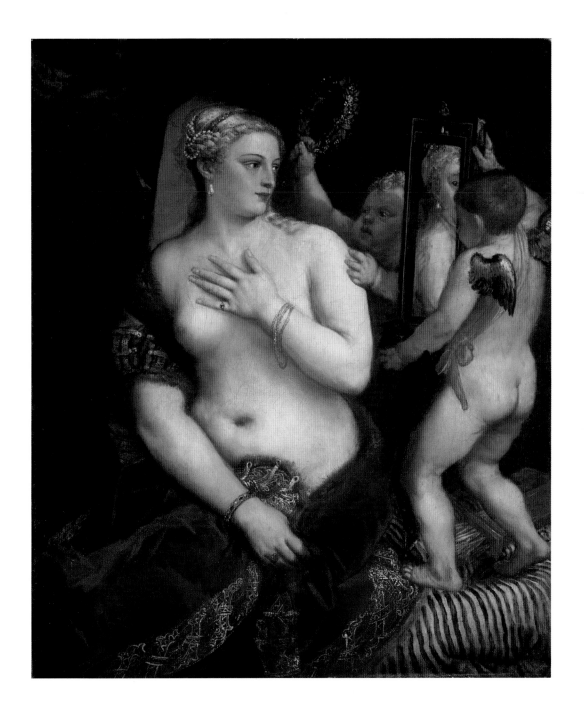

Entombment

1559
Oil on canvas, 130 × 168 cm
Madrid, Museo Nacional
del Prado
Signed "TITIANUS VECELLIUS
AEQUES CAES."

The theme of the entombment of Christ was tackled by Titian on several occasions: in a painting dating back to the 1520s and now in the Louvre, in which the tomb is shown as a cavity carved out of the rock, according to the Gospel accounts; followed by this work, commissioned in 1556 by Philip II to replace another of the same subject lost two years earlier during shipping to Flanders; and finally in a canvas dated around 1565, also housed in the Prado, which is probably the one seen by Vasari in the artist's Venice studio in 1566.

Titian sent this work to Philip II in 1559, along with the two 'poems', *Diana and Actaeon* and *Diana and Callisto.* The painting was moved to the high altar of the Escorial Church, the burial place of Charles V, in 1574. However, during the Napoleonic invasion it was seized and mutilated on all four sides. After its return to Spain, it was placed in another part of the monastery before entering the Prado museum in 1837.

In this painting the artist has given the theme of the entombment of Christ emotionally dramatic overtones, effectively conveyed by the broken and almost rough application of color that is a key feature in the representation of the scene. In this masterpiece of Titian's mature years the naturalism of the Louvre version is replaced with an expressionistic, dramatic, and anxiety-wrought language in which the figures appear to disintegrate. The composition is enclosed and almost compressed within the limits of the canvas, so that there is no visible setting apart from the backlit rocky wing that forms the left border, and the opening of the blue sky shot through with red gleams behind the desperate figure of Mary Magdalene who stands over the lifeless Christ borne by Joseph of Arimathea, to whom the elderly Titian has given his own features.

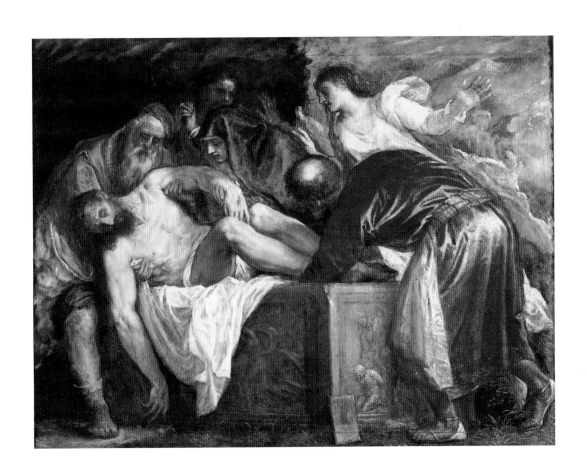

Annunciation (Incarnation)

1560–1565
Oil on canvas, 403 × 235 cm
Venice, San Salvador
Signed "TITIANUS FECIT FECIT";
part of the original signature
"FACIEBAT"

This painting was commissioned from Titian in 1559 by the rich merchant Antonio Cornovì della Vecchia as an altarpiece for his funerary chapel in the Augustinian church of San Salvador in Venice. The work was probably painted between 1560 and 1565 and depicts the Annunciation, or more precisely the actual fulfillment of the message through the mystery of the Incarnation, as indicated by a series of elements that do not belong to the traditional iconography of the theme. Indeed, the angel Gabriel does not carry the usual lily of purity, but crosses his arms over his chest in a pose generally reserved for the Virgin. The Virgin herself is not shown as a frightened girl, but as a knowing and serene woman; she holds her veil away from her face, not in an attempt to hide it (as in the old funerary stele belonging to the Grimani collection, which probably inspired Titian), but uncovering it and letting it be flooded with the divine light that falls from above (where the dove of the Holy Ghost appears among a triumph of angels), in a gesture of complete acceptance of the miraculous event. A vase in the lower right corner contains red flowers that allude to Mary's virginity, which is as perpetual and incorruptible as fire, as specified by the inscription beneath it (*Ignis ardens non comburens*).

The other inscription that appears in the lower register of the canvas postdates Titian's work. It reads *Titianus fecit fecit*, in which the repetition of the verb was traditionally interpreted as a proud declaration by the painter of his value as an artist, but x-ray examination of the canvas has shown that it was originally signed TITIANUS FACIEBAT. Titian's contemporaries, including Vasari, did not fully appreciate this painting, which they considered disturbingly innovative due to the perfunctory brushstrokes of shimmering color and the revolutionary use of light, which creates incandescent gleams.

142

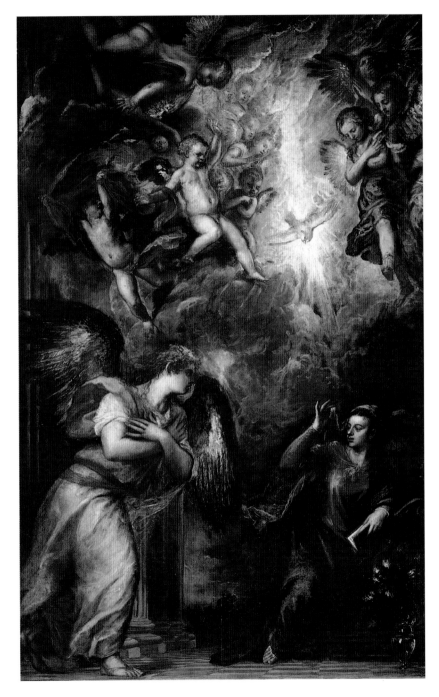

Self-portrait

c. 1562
Oil on canvas, 96 × 75 cm
Berlin, Staatliche Museen
zu Berlin, Preußischer
Kulturbesitz, Gemäldegalerie

Together with the canvas housed in the Prado, this is one of just two undoubtedly authentic self-portraits of Titian to have survived (in addition to numerous likenesses of himself that the artist 'hid' in his religious or mythological paintings). Some scholars date the portrait to around 1550, noting how the painter's appearance was still vigorous and his beard thick. However, it is more likely to have been painted around 1562 (Palluchini, Valcanover, Pignatti, Rossi), and this date is confirmed by the palette of soft colors and the rapid and irregular brushstrokes typical of the artist's late works. Those who favor this later date identify the painting with the self-portrait that Vasari saw in Titian's home in 1566 and described in the 1568 edition of *The Lives of the Artists*: "A very fine and natural portrait of himself that he completed about four years ago."

The composition of the work is very straightforward and effective. Unlike the painting in the Prado, it does not feature any tools that hint at the painter's trade, and the only element that recalls Titian's actual life is the chain that stands out against his light-colored shirt, the insignia of the dignity of Knight of the Golden Spur, which was bestowed on him by Charles V in 1533. The psychological characterization of the subject is entirely entrusted to the physical features and pose of the figure, which majestically occupies the space with its energetic and determined stance, restrained movement of the upper body and wide shoulders, and vigorous tension of the hands. The face, strongly modeled by the light, is resolutely turned to the subject's left and effectively expresses the pride and awareness that are the key elements of Titian's personality and the legend that he had managed to build around himself (Paola Rossi). The self-portrait was originally housed in the Venetian home of the Barbarigo di San Raffaele family, before passing to the Solly collection in Berlin, from which it was purchased by the museum in 1821.

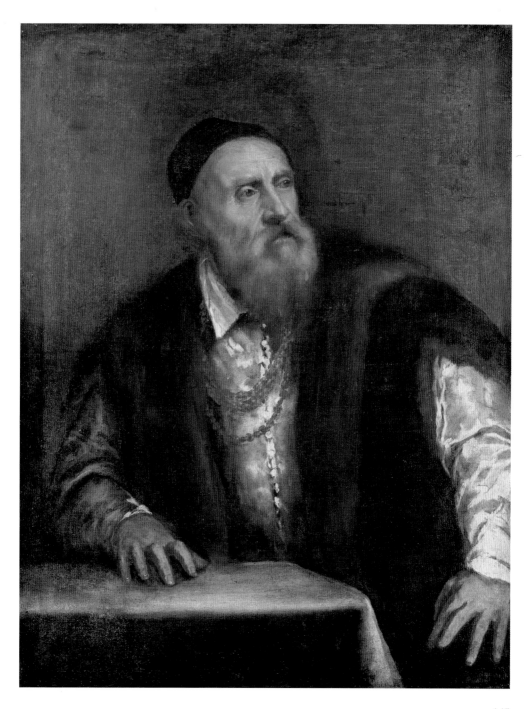

The Penitent Magdalene

1565
Oil on canvas, 118 × 97 cm
St Petersburg, The State
Hermitage Museum

The work in the Hermitage depicting the repentant Mary Magdalene is signed by Titian, who painted it around 1565, and is the finest of his numerous versions of this subject. Ridolfi recorded six versions of the painting in 1648, of which only two can be identified today; one, probably by the artist's workshop, now in Capodimonte, and the Hermitage masterpiece. The artist himself must have been very attached to this work, for he kept it in his home until his death in 1576. In 1581 his son, Pomponio Vecellio, sold it to the Barbarigo di San Raffaele family and it became the finest work of their extensive collection. The canvas was purchased by the Russian museum in 1850.

The penitent saint is set in a shady landscape, naturalistically captured at twilight, in which each figure and object is swathed in a dim and opaque light. In the foreground is a smooth, white skull supporting an open book and, on the left, a crystal vessel holding myrrh, pierced by cool glints. The center of the scene is occupied by the figure of Mary Magdalene, with long loose hair and a light, white robe beneath a silk shawl. According to Ridolfi, Titian copied her pose, face with tear-filled eyes staring at the sky, and arms clutching her breast from an antique statue. The painting was highly regarded by the artist's contemporaries, and Vasari in particular, who praised its power to engage the observer emotionally. Its greatest quality is the masterly way in which Titian exploited the potential offered by the technique of oil painting to describe the texture of each detail with vivid and almost tactile realism, from the fabrics of the garments and the crystal of the ointment jar to the warmth of Magdalene's fine hair and the splendid reddened, tear-streaked face.

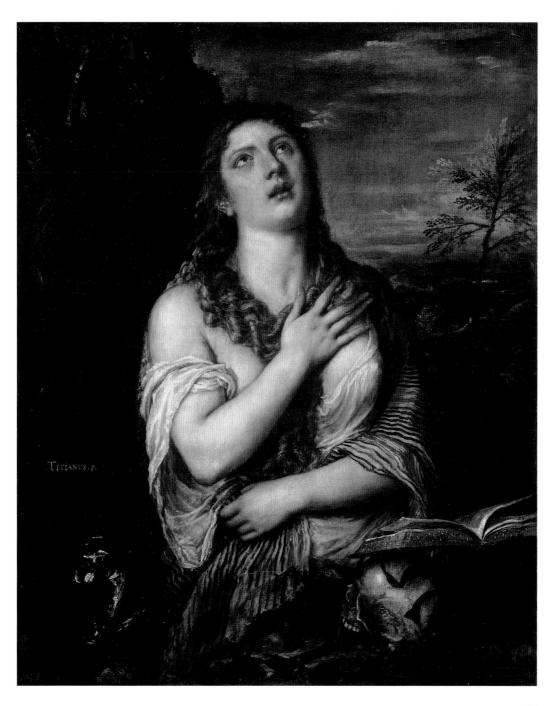

147

Venus Blindfolding Cupid

c. 1565
Oil on canvas, 118 × 185 cm
Rome, Galleria Borghese

This work, which was probably sold to Scipione Borghese by Cardinal Sfondrato in 1608, was painted around 1565 during a period that the artist spent in his native region of Cadore, the mountains of which are visible in the background. It is not easy to identify the subject: indeed, the work is not mentioned in contemporary documents, and the first texts that describe the painting, in the seventeenth century, variously interpret it as *Venus Blindfolding Cupid Flanked by Two Nymphs* or *The Three Graces* (following an ancient tradition, revived in the seventeenth century, according to which Venus was one of the Three Graces). The majority of modern critics have interpreted the painting from a moralistic and educational viewpoint, identifying the subject as the Education of Cupid, blindfolded and thus blind, according to a tradition begun by Petrarch's *Triumphs*, which subsequently became extremely popular in literary and iconological texts, as well as woodblock prints and Renaissance tarot cards.

Panofsky (1939 and 1969) has instead suggested a Neoplatonic reading of the scene: the sighted Cupid, leaning on Venus's shoulder with a melancholy air, represents celestial love (Anteros), who raises the human soul to the contemplation of God, while his blindfolded counterpart is earthly love (Eros). The two nymphs have been interpreted as allegories of conjugal love (or Pleasure) and Chastity. The work certainly represents the characteristic sense of dramatic fatality of the sentiment of love, embodied here by the determined, and at the same time almost indifferent, attitude of Venus, who directs her gaze beyond the other figures and the viewer. It is also reinforced by the sadness of the sighted Cupid, the movement of the nymph arriving with a bow of dimensions better suited to Apollo than Cupid, and the fiery tones of the sky at sunset in the background, which contrast with the blues of Venus' cloak, the cupids' wings, and the pale blue mountains.

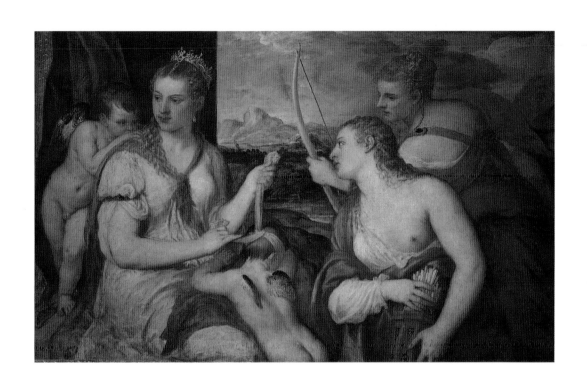

Portrait of Jacopo Strada

1568
Oil on canvas, 125 × 95 cm
Vienna, Kunsthistorisches
Museum
Signed "TITIANUS F."

The portrait, commenced by Titian in 1567 and completed the following year, entered the collection of Archduke Leopold Wilhelm of Habsburg in 1659 before passing to the Kunsthistorisches Museum. As documented by the inscription in the gilded frame in the top right corner of the painting, the subject is Jacopo Strada, a collector and antique dealer who served the Habsburgs. Titian himself had a close relationship with Strada; during the same year in which he completed this portrait, he offered several of his mythological paintings to the Emperor Maximilian II through the dealer.

This work is one of Titian's masterpieces of portraiture and is very different from the rigid likenesses of the official portraits, characterized by detached and detailed description, which pervaded the European courts of the period. Strada is portrayed in a room surrounded by objects that recall his prestigious and refined profession: the small statue of Venus between his hands, the books lying on a shelf in the upper part of the painting, and the coins scattered over the table. His jewellery, sword, sumptuous garments, and fur-trimmed cloak also contribute to defining his exceptional social status. The figure has been captured in a dynamic pose brimming over with restrained energy; the antiquarian's face is energetically turned to the right, as he gazes determinedly and proudly beyond the viewer. This is thus an 'action portrait' in which Titian has not only captured the personality and role of the subject, but also his sensitivity and emotions. This perspicacious psychological probing is expressed in rapid and approximate brushstrokes: the color is applied in quick and sometimes rough strokes, using an impressionistic style that seems to leap forward in time to demand comparison with Rembrandt at his best.

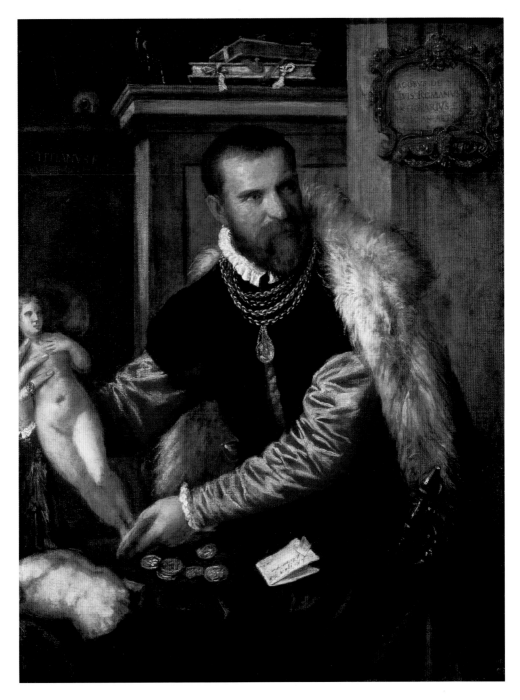

151

Christ Crowned with Thorns

c. 1570
Oil on canvas, 280 × 181 cm
Munich, Alte Pinakothek

Titian tackled the theme of Christ crowned with thorns in two works painted almost 30 years apart. The first, which is now in the Louvre, was commissioned for the Milanese church of Santa Maria delle Grazie between 1542 and 1544 and is the result of Titian's ingenious assimilation of Tuscan and Roman mannerism. The scene of the Passion is depicted in a Classical architectural setting that echoes Giulio Romano's Mantuan works and is embellished with antique references. Even the vigorously plastic figures in elegant twisted poses testify to the artist's attention to Classical sculptural models and the innovations developed by Michelangelo. Around 1570 Titian picked up the theme and the compositional layout of the Louvre painting again, but the style of this second work reveals considerable development in relation to the earlier one. The learned references to Classical architecture and statuary have disappeared from the architecture framing the scene, which is replaced by a simple archway that opens onto an overcast sky with racing clouds, while a lamp appears in the upper right corner to illuminate the dramatic scene. The meticulous rendering and sculptural quality of the 1540s painting is replaced here with the quick, vibrant, and almost rough application of color that mottles the canvas in a reduced palette of golden browns. These almost appear monochrome from a distance, but are actually composed of infinite shades revealed in the light. This revolutionary technique, typical of Titian's late work, is perfectly suited to translate and accentuate the dramatic aspects, expressive tension, and bitterly pessimistic reflections of the elderly master in his final paintings, both religious and mythological.

Ridolfi and Boschini both mention a very interesting fact regarding this painting: as part of Titian's legacy, it was bequeathed to Jacopo Tintoretto and subsequently to the latter's son, Domenico.

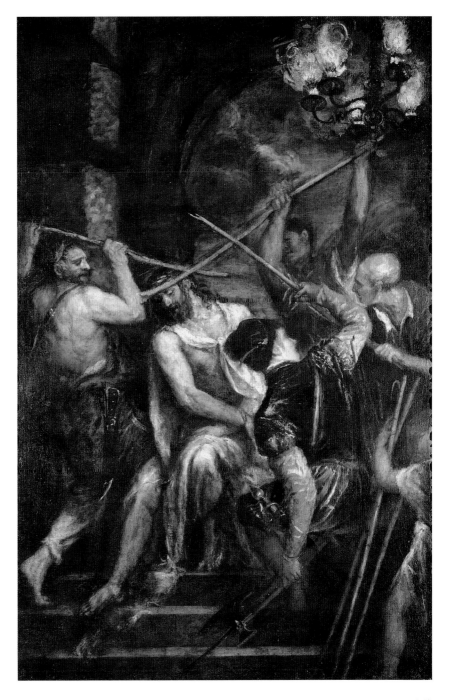

153

Saint Sebastian

c. 1570
Oil on canvas, 210 × 115.5 cm
St Petersburg, The State
Hermitage Museum

The large painting of the martyr Sebastian pierced with arrows arrived at the Hermitage museum in 1850 from the heirs of Cristoforo Barbarigo, who had purchased the work together with Titian's house in 1581. The painter had originally intended to paint a half-length portrait of the saint, but subsequently enlarged the canvas, adding other features on the right and lower sides after having decided to depict the entire figure. Saint Sebastian's body emerges in its heroic nudity (according to Brendel, Titian modeled the body on the Belvedere Apollo and the face on one of the sons of Laocoön in the famous Hellenistic sculptural group) from the darkness of the undefined landscape illuminated by gleams of light that streak the sombre evening sky and the quivering flames of the fire roughly depicted on the left of the painting. The work, painted in dull shades of brown with countless graduations of ochre, olive green, gold, and red features quick, flowing brushstrokes that delineate a scene in which the details of the real world disappear, almost as though "the earth, water and air had returned to the state of primitive chaos" (Lionello Venturi).

Indeed, Titian's *Saint Sebastian* is highly representative of his late work, which was characterized by an exceptionally fluent yet perfunctory pictorial technique, ideal for accentuating the dramatic dimension of religious and mythological scenes and capable of engaging the viewer emotionally. Many of the artist's contemporaries did not appreciate these works, which were still misunderstood several centuries later. When this painting arrived at the Hermitage it was placed in storage, where it remained until 1912, described in the museum catalogues as a preparatory work or an unfinished sketch. The interest of art critics in this *Saint Sebastian* is only a recent development, stemming from a new interest in Titian's late style. The painting has been dated to around 1570 and reassessed to the point of being considered one of the artist's masterpieces.

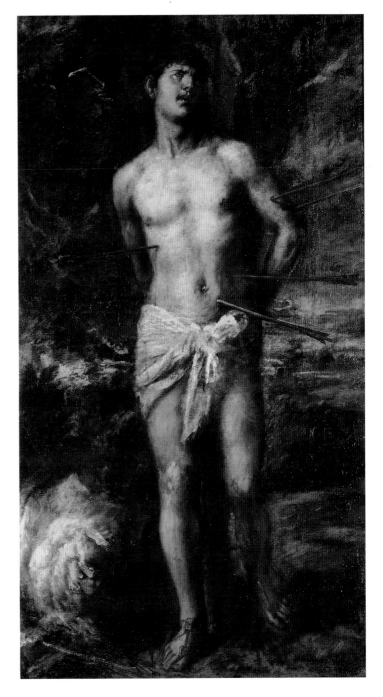

Tarquin and Lucretia

c. 1570
Oil on canvas, 114 × 100 cm
Vienna, Gemäldegalerie
der Akademie der Bildenden
Künste

The Etruscan prince Tarquin's violent attack upon Lucretia, the young wife of Collatinus, described by Livy and Ovid, formed the subject of three works by Titian, all painted during the last years of his life. The first of these was commissioned by Philip II and is now housed in the Fitzwilliam Museum in Cambridge, the second is a variation of the first painting and was largely painted by the master's workshop, while the third is this canvas conserved in Vienna.

As in other cases, Titian produced an official version of the theme—the one for the king of Spain, in which he depicted Lucretia's tragedy based on Livy's account, paying meticulous attention to the description of details with the utmost pictorial perfection—and a 'private' version, in which he abandoned the detailed description of the setting and concentrated on the psychological and emotional aspects of the scene. In the Vienna painting the figures of Tarquin and Lucretia are depicted close up in a flat, neutral setting that has practically no depth. Lucretia, here depicted fully clothed, unlike most of the pictorial representations of the same period, seems to emerge from nowhere at the lower edge of the painting, and opposes Tarquin's violence with a strong twist of her body that makes her lean towards the viewer. The Etruscan prince flings himself violently at the young woman, immobilizing her right arm with one hand and grasping a dagger in the other. The colors of the painting are muted and applied with broad, dense, and undefined brushstrokes. Several details, including the stroke of thick color on Tarquin's side and on the sleeve of Lucretia's gown, appear to indicate that the painting is unfinished. However, as it was conceived in the impressionistic and unfinished style of Titian's last years, it was probably interrupted when only the final finishing layers were missing.

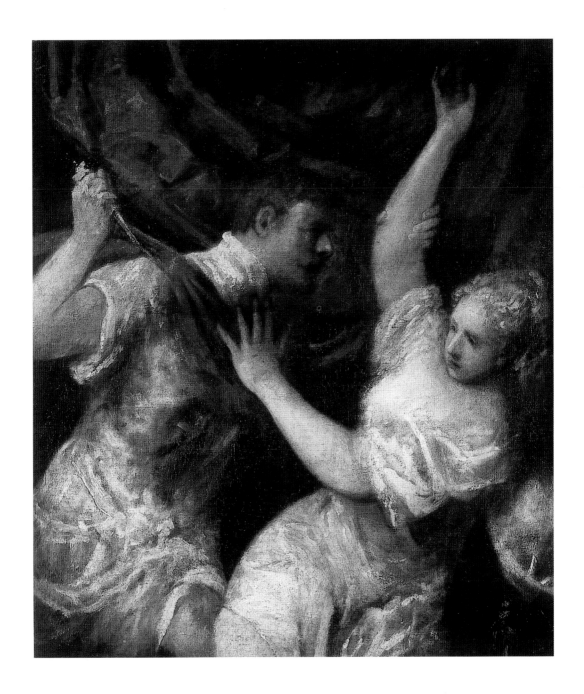

Doge Antonio Grimani Kneeling Before the Faith

1570–1575
Oil on canvas, 373 × 496 cm
Venice, Ducal Palace,
Sala delle Quattro Porte

This work is the only one of Titian's votive paintings of the doges to have escaped the fires that broke out in the Doges' Palace in 1574 and 1577. The reason for this is that, though the painting was commissioned by the Council of Ten in 1555, it long remained in the painter's workshop and was only placed in the Sala delle Quattro Porte of the palace following the artist's death and after having been altered (in the figures of the prophet and the standard-bearer) by Marco Vecellio or another of Titian's pupils. The work was not commissioned by Grimani, as was the usual practice, but requested several years after his death, to avoid breaking the tradition and to honor his memory. Before becoming doge, Grimani had served as the 'Capitano Generale da Mar'. This office had caused him bitter disappointment (the defeat by the Turks at Zonchio in 1499 and his subsequent trial by the Venetian Republic) and even humiliation (his public repentance in chains) prior to his rehabilitation and election as doge. This explains why Titian has not portrayed the doge in his ducal robes, but in armor, i.e. in the guise of the *miles christianus*, emphasizing his role as a defender of the Faith. Antonio Grimani's open-armed pose, which recalls that of Saint Francis receiving the stigmata, and the conical ducal headdress borne by a page, reveal the painter's intent to give the doge an image of humility and intense devotion. Titian has ably interpreted the ideological and political message that Grimani's leadership expressed, emphasizing the intensity of his dialogue with the personification of Faith, shrouded in light, surrounded by angels, and bearing the symbols of the cross and chalice. The figure of Saint Mark, who raises his eyes towards the heavenly apparition, is depicted on the right, while the background features a luminous view of Venice and its harbor crowded with ships, the symbol of its naval power, which is celebrated despite the memory of the defeat that accompanied the figure of the doge.

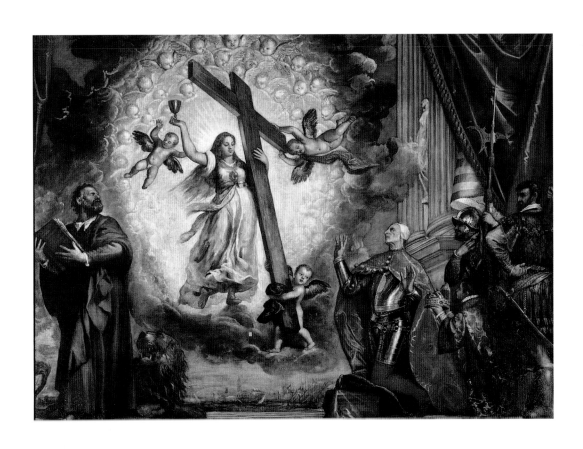

The Flaying of Marsyas

1570–1576
Oil on canvas, 212 × 207 cm
Kroměříž, Archbishop's Palace
Signed "TITIANUS P."

The famous *Flaying of Marsyas*, conserved in the gallery of the Archbishop's Palace in Kroměříž, is one of the greatest masterpieces of Titian's late style. The artist painted it towards the end of his life, between 1570 and 1576, with the large areas of almost incandescent color that were typical of his late work.

It depicts the Phrygian satyr Marsyas flayed alive by Apollo after the god had been defeated by Marsyas in a musical contest in which he had played the lyre and the satyr played the flute. The tragic scene of the punishment also features a young man playing the lyre, interpreted by some as a second figure of Apollo and by others as Olympus. X-ray examinations have revealed that Titian had originally painted a lyre-bearer in this position, which was later replaced—perhaps by one of his pupils—with the definitive figure. On the right sits the sad and thoughtful figure of King Midas with his ass's ears, the symbol of the punishment inflicted on him by Apollo, whom he had offended by choosing Pan as the winner in a previous musical contest.

According to Augusto Gentili's interpretation of the painting, Titian's intention in depicting this tragic subject was to represent the end of the natural and primitive world, embodied by Marsyas, and the beginning of rational civilization and harmony, represented by Apollo. This epochal turning point was viewed by the painter with a sense of aching melancholy, embodied in the figure of Midas, who looks on powerless. A self-portrait of Titian has been identified in the face of the king who could turn all that he touched into gold, but who belonged to the defeated civilization: like the mythological figure, the artist had also been granted the gift of turning any material into gold by means of his brush. The melancholy air of Titian-Midas seems to indicate his awareness that this gift is transitory and irrelevant in the face of violence and the tragic, inevitable progression of the history of mankind.

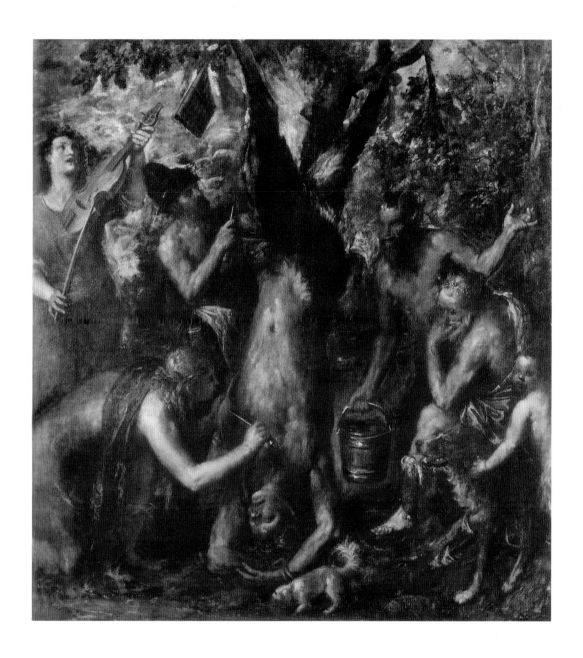

Religion Succored by Spain

1572–1574
Oil on canvas, 168 × 168 cm
Madrid, Museo Nacional
del Prado
Signed "TITIANUS F"

This large painting is an allegorical celebration of the naval victory of the Holy League, composed of papal, Venetian, and Spanish forces led by Don John of Austria, the half-brother of Philip II of Spain, over the Ottoman Turks at Lepanto on October 7, 1571. A month after the event, Venice's Council of Ten invited Titian to paint a large work depicting the naval battle for the Sala dello Scrutinio in the Doges' Palace. However, the artist did not respond promptly to the request, causing the commission to be transferred to Tintoretto, who painted the canvas in 1573. Titian was more attentive with Philip II, for whom he painted two works intended to glorify the Habsburg dynasty and its role in the triumph over the Turks. The two paintings, which are both now in the Prado, were sent to Spain in 1575. The first depicts the king of Spain offering his son, the Infante Don Fernando, born exactly two months after the battle, to Victory. For the second, *Religion Succored by Spain*, Titian managed to reuse and convert an old work with a mythological theme showing the triumph of Virtue over Vice, which he had commenced for the duke of Ferrara, Alfonso I d'Este, and never completed due to the client's death in 1534 (Vasari saw it in Titian's studio in 1566).

The original figure of Venus, on the right, was demurely covered with drapery in the personification of the Christian Religion, flanked by the attribute of a cross and prostrated by the threat of the Turks. The personification of Spain, originally the figure of Minerva, is depicted coming to her rescue on the right, bearing the standard and trampling the weapons that symbolize military triumph. A Turk can be seen sinking into the sea in the background, which Titian created by repainting and modifying the original figure of Neptune (the origins of the work were reconstructed and studied, with the aid of x-ray examination, by Wittkover, Pallucchini, Mason Rinaldi, and Panofsky).

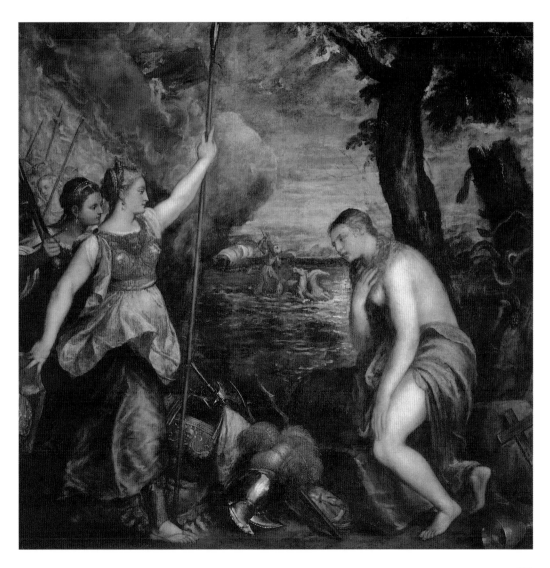

Pietà

c. 1575
Oil on canvas, 378 × 347 cm
Venice, Gallerie
dell'Accademia

This large canvas was designed by Titian for the Chapel of Christ in the church of Santa Maria dei Frari, where the artist had obtained permission to be interred, as testified by Ridolfi. However, for some unknown reason the work remained in the painter's house and, upon his death during an outbreak of the plague on August 27, 1576, Titian was buried in the chapel with a hurried state funeral without his painting. The work subsequently passed to Palma Giovane, who made several changes (including the cupid bearing the torch and the inscription in the middle of the lower edge), before being moved to the now destroyed church of Sant'Angelo, probably in 1631, from which it was transferred to the Accademia in 1841. The work was thus devised to adorn Titian's tomb, and the artist transformed it into a sort of enormous ex-voto aimed to avert the danger of the plague. The scene is depicted in an architectural setting that echoes Giulio Romano's Mantuan works, flanked by a pair of statues of Moses, the Old Testament prefiguration of Christ, and the Hellespontine Sibyl, who foretold the Crucifixion and the Resurrection, both of which stand on pedestals carved with lion protomes that refer to Saint Mark, but also to divine knowledge.

In the center, painted with dense color and approximate brushstrokes, are the figures of the Virgin, with the livid body of the dead Christ in her arms, Mary Magdalene, shown in a pose of desperate anguish, and a semi-nude prostrate old man, on the right, which is a self-portrait of Titian. Like Michelangelo in the *Pietà* destined for his own tomb, Titian has depicted himself in the act of requesting divine intercession, a prayer that is made explicit in the votive tablet—a painting within the painting—shown in the right margin of the work, in which Titian and his son Orazio beseech the Virgin for salvation from the plague. The desperate plea for divine protection is reinforced by the disquieting arm reaching up from the feet of the statue of the Sibyl that constitutes a last, tragic symbol of the anguish of the artist close to death.

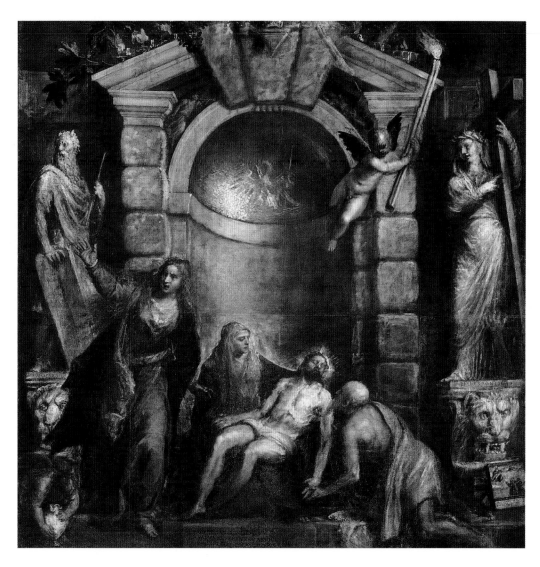

Appendix

Venus of Urbino
(detail), 1538
Florence, Galleria degli Uffizi

Chronological Table

	The Life of Titian	Historical and Artistic Events
1480–1485	Titian is born in Pieve di Cadore to an influent local family.	
1502		The allied Spanish, Venetian, and papal fleets (the last commanded by Jacopo Pesaro) defeat the Turks at the battle of Santa Maura.
1503	He paints the altarpiece conserved in Antwerp for Jacopo Pesaro, bishop of Paphos.	Venice signs a peace agreement with the Turks. On December 7 Julius II della Rovere, who has just been elected pope, condemns the Venetian conquests in Romagna.
1508	He works on the frescoes on the façade of the Fondaco dei Tedeschi while Giorgione frescoes the façade of the same building that faces onto the Grand Canal.	The League of Cambrai is formed by the pope, the emperor, Spain, France, and a few Italian states against the Republic of Venice.
1509		Andrea Gritti, commander of the Venetian army and future doge, wins back Padua; Sebastiano del Piombo paints the organ doors for the Venetian church of San Bartolomeo.
1510		Julius II removes the excommunication order he placed on Venice. The Venetian painter Giorgione dies.
1511	He paints the three frescoes for the Scuola di Sant'Antonio in Padua.	
1513	He is invited to the papal court in Rome by Pietro Bembo but refuses, preferring to offer his services to the Republic of Saint Mark.	Julius II dies and is succeeded by Leo X de' Medici; Pietro Bembo is made pontifical secretary. In Venice Giovanni Bellini paints the *Saint John Chrysostom Altarpiece*.
1516	From January 31 to March 22 he stays at the court of Alfonso I d'Este, Duke of Ferrara. The same year he receives the prestigious commission for the *Assumption of the Virgin* for the church of Santa Maria Gloriosa dei Frari.	The Venetian army wins back Brescia. Giovanni Bellini dies on November 29.
1517	He obtains the Senseria of the Fondaco dei Tedeschi, a position that had become vacant after the death of Giovanni Bellini.	Luther nails the 95 theses on the door of Wittenburg Cathedral.

The Life of Titian	Historical and Artistic Events
1518 The altarpiece of the Frari, the *Assumption*, is inaugurated on May 19. During that period Titian works on paintings for the 'Alabaster Chamber' of the Duke of Ferrara.	Jacopo Robusti (called Tintoretto) is born in Venice.
1519 Jacopo Pesaro commissions from Titian the altarpiece of the *Immaculate Conception* for the church of the Frari.	Emperor Maximilian I dies and is succeeded by Charles V, who unites the kingdom of Spain to the Habsburg Empire.
1520 The artist begins work on the *Averoldi Polyptych*.	
1523 He visits Ferrara and his relationship with Federico II Gonzaga, Marquis of Mantua begins; in Venice he frescoes a chapel in the Ducal Palace for the doge, Andrea Gritti.	On the death of Antonio Grimani, Andrea Gritti is elected doge of Venice.
1525 He marries Cecilia, by whom he already has two sons, Pomponio and Orazio.	Lorenzo Lotto works at the convent of Santi Giovanni e Paolo in Venice.
1527 Through Pietro Aretino, Titian offers Federico II Gonzaga two portraits.	In May the imperial troops of the Lanzichenecchi sack Rome.
1528 He receives the commission for the *Saint Peter Martyr Altarpiece* for the church of Santi Giovanni e Paolo. His wife Cecilia dies.	
1530 To mark the coronation of the emperor, Titian is called to Bologna to paint a portrait of Charles V in armor.	Charles V is crowned king of Italy and emperor of the Holy Roman Empire in Bologna by Pope Clement VII.
1531 He paints the votive portrait of Doge Andrea Gritti for the Sala del Collegio in the Ducal Palace.	
1532 His relationship with Francesco Maria della Rovere, Duke of Urbino, begins.	
1533 He portrays Charles V again during a second stay in Bologna; having returned to Spain, the emperor appoints Titian Count of the Lateran Palace, Aulic Council and Consistory, Palatine Count, and Knight of the Golden Spur with the right of access to the Spanish court.	

	The Life of Titian	Historical and Artistic Events
1538	He begins work on the *Venus of Urbino* for duke Guidobaldo II della Rovere; from a medal made by Benvenuto Cellini he portrays the king of France, François I.	The Holy League is defeated by the Turks at Prevesa.
1540	He paints the *Christ Crowned with Thorns* (Louvre) for the Milanese church of Santa Maria delle Grazie.	
1541	He delivers the *Address* (Prado) to Alfonso d'Avalos in Milan; he produces the first version of the *Pentecost Altarpiece*.	Giorgio Vasari visits Venice.
1542	He makes the portrait of Ranuccio Farnese and the paintings for the ceiling of Santo Spirito in Isola.	Lorenzo Lotto paints *Saint Antonino Distributing Alms* for the church of Santi Giovanni e Paolo in Venice; Vasari paints the ceiling of a room in the Palazzo Corner Spinelli in the same city.
1545	After a short stay in Pesaro and Urbino, on October 9 Titian arrives in Rome, where he is welcomed to the papal court. He paints the *Danaë* for Cardinal Alessandro Farnese and several portraits of the pope's family.	The Council of Trent opens (and ends in 1563).
1546	After being awarded Roman citizenship on March 16, the artist returns to Venice.	
1548	In January he travels to the German city of Augusta, where he paints a number of portraits, including that of Charles V on horseback.	During Titian's absence from Venice, Jacopo Tintoretto paints the *Miracle of Saint Mark Freeing the Slave* for the Scuola Grande di San Marco.
1550	He returns to Augusta at the invitation of Philip II and Lucas Cranach prints his portrait. From this year, Titian regularly sends the Spanish king paintings of mythological and religious subjects.	The first edition of Giorgio Vasari's *Lives of the Artists* is published.
1555	He completes the portrait of Doge Francesco Venier, and receives the commission for the votive painting of Doge Antonio Grimani.	

The Life of Titian	Historical and Artistic Events
1556	Charles V abdicates and the imperial crown passes to his brother Ferdinand I, while his son Philip II inherits the crown of Spain.
1557 Titian and Sansovino are members of the committee to choose artists to be employed on the decoration of the ceiling of the Libreria Marciana.	The church of San Geminiano, designed by Sansovino, is completed in Saint Mark's Square.
1559 *The Martyrdom of Saint Lawrence*, commissioned from Titian in 1548, is placed on the altar of the Crociferi in the church of the Jesuits in Venice. In a letter dated June 12, he informs Philip II of the attempt on the life of his son Orazio by the medallist Leone Leoni in Milan.	The Peace of Cateau Cambresis ends the religious war in Europe and establishes the dominance of Spain and the Habsburgs over many of the Italian territories. The Vatican's list of prohibited books is instituted by Pope Paul IV.
1564 He sends the *Last Supper,* to Philip II, begun in 1558.	Tintoretto begins work on the decoration of the Scuola Grande di San Rocco.
1566 With Andrea Palladio and Jacopo Tintoretto he is elected a member of the Accademia del Disegno of Florence.	Pope Pius V Ghislieri is elected. Vasari is in Venice, where he gathers material for the second edition of his *Lives* and meets Titian.
1568 He completes the portrait of Jacopo Strada, a collector and antiquarian for the Habsburgs.	Vasari publishes the second edition of his *Lives*.
1570	The Turks occupy the Venetian fortress in Cyprus. Jacopo Sansovino dies in Venice.
1571 In a letter to Philip II Titian claims to be 95 years old.	The Holy League defeats the Turkish fleet at Lepanto on October 7.
1573 Titian paints the canvas of *Philip II Offering the Infante Don Fernando to Heaven* to celebrate the victory of Lepanto over the Turks.	On March 7 Venice signs a separate peace with the Turks, in which it cedes Cyprus.
1575	An epidemic of the plague strikes Venice.
1576 On August 27 Titian dies in his house in Biri Grande and the next day is buried in the church of Santa Maria dei Frari. His house, having been left empty, is looted.	

Geographical Locations of the Paintings

in public collections

Italy

Averoldi Polyptych
Oil on panel, 278 x 122 cm,
170 x 65 cm, 170 x 65 cm,
79 x 85 cm, 79 x 85 cm
Brescia, church of Santi
Nazzaro e Celso
1520–1522

The concert
Oil on canvas,
86.5 x 123.5 cm
Florence, Galleria Palatina
di Palazzo Pitti
1507–1508

Flora
Oil on canvas,
79,7 x 63.5 cm
Florence, Galleria degli Uffizi
c. 1515

*Portrait of a Gentleman
(Tommaso or Vicenzo
Mosti)*
Oil on canvas, 85 x 67 cm
Florence, Galleria Palatina
di Palazzo Pitti
1520 (?)

*Portrait of Eleonora
Gonzaga Della Rovere*
Oil on canvas, 114 x 103 cm
Florence, Galleria degli Uffizi
1536–1537

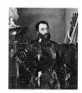

*Portrait of Francesco Maria
Della Rovere*
Oil on canvas, 114 x 103 cm
Florence, Galleria degli Uffizi
1536–1537

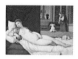

Venus of Urbino
Oil on canvas, 119 x 165 cm
Florence, Galleria degli Uffizi
1538

Portrait of Pietro Aretino
Oil on canvas,
96.7 x 76.6 cm
Florence, Galleria Palatina
di Palazzo Pitti
1545

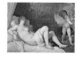

Danaë
Oil on canvas, 120 x 172 cm
Naples, Museo e Gallerie
Nazionali di Capodimonte
c. 1545

*Pope Paul III with his
Nephews Alessandro
and Ottavio Farnese*
Oil on canvas, 210 x 174 cm
Naples, Museo e Gallerie
Nazionali di Capodimonte
1546

Italy

The Miracle of the Jealous
Husband
Fresco, 327 x 183 cm
Padua, Scuola del Santo
1511

Sacred and Profane Love
Oil on canvas, 118 x 278 cm
Rome, Galleria Borghese
1514–1515

Venus Blindfolding Cupid
Oil on canvas, 118 x 185 cm
Rome, Galleria Borghese
c. 1565

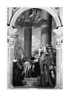

Saint Mark enthroned
with Saints
Oil on panel, 218 x 149 cm
Venice, Santa Maria
della Salute
1510

Assumption of the Virgin
Oil on panel,
690 x 360 cm
Venice, Santa Maria
Gloriosa dei Frari
1516–1518

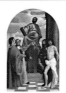

Pesaro Altarpiece
Oil on canvas,
478 x 266.5 cm
Venice, Santa Maria
Gloriosa dei Frari
1518–1526

Annunciation
Oil on canvas, 166 x 266 cm
Venice, Scuola Grande
di San Rocco
c. 1522

The Presentation of the
Virgin in the Temple
Oil on canvas,
335 x 775 cm
Venice, Gallerie
dell'Accademia
1534–1538

Saint John the Baptist
Oil on canvas, 201 x 134 cm
Venice, Gallerie
dell'Accademia
c. 1540

Pentecost
Oil on canvas,
570 x 260 cm
Venice, Santa Maria
della Salute
c. 1546

Italy

*The Martyrdom
of Saint Lawrence*
Oil on canvas, 493 x 277 cm
Venice, church of the
Jesuits
1548–1557

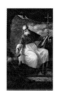

Saint John the Almsgiver
Oil on canvas, 229 x 156 cm
Venice, San Giovanni
Elemosinario
c. 1550

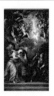

Annunciation (Incarnation)
Oil on canvas, 403 x 235 cm
Venice, San Salvador
1560–1565

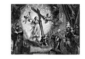

*Doge Antonio Grimani
Kneeling before the Faith*
Oil on canvas, 373 x 496 cm
Venice, Ducal Palace,
Sala delle Quattro Porte
1570–1575

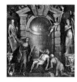

Pietà
Oil on canvas, 378 x 347 cm
Venice, Gallerie
dell'Accademia
c. 1575

Austria

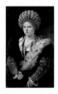

Portrait of Isabella D'este
Oil on canvas, 102 x 64 cm
Vienna, Kunsthistorisches
Museum
1534–1536

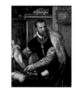

Portrait of Jacopo Strada
Oil on canvas, 125 x 95 cm
Vienna, Kunsthistorisches
Museum
1568

Tarquin and Lucretia
Oil on canvas, 114 x 100 cm
Vienna, Gemäldegalerie der
Akademie der Bildenden
Künste
c. 1570

Belgium	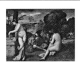	*Jacopo Pesaro presented by pope Alexander VI to Saint Peter* Oil on canvas, 145 x 183 cm Anverse, Musée Royal des Beaux–Arts 1503–1506	
France		*Pastoral Concert* Oil on canvas, 110 x 138 cm Paris, Musée du Louvre 1509–1510	*Man with a Glove* Oil on canvas, 100 x 89 cm Paris, Musée du Louvre 1520–1523
Germany		*Self-portrait* Oil on canvas, 96 x 75 cm Berlin, Staatliche Museen, Gemäldegalerie *c.* 1562	*Christ Crowned with Thorns* Oil on canvas, 280 x 181 cm Munich, Alte Pinakothek *c.* 1570
Great Britain		*The Three Ages of Man* Oil on canvas, 90 x 150.7 cm Edinburgh, National Gallery of Scotland 1512–1513	*Bacchus and Ariadne* Oil on canvas, 175 x 190 cm London, National Gallery 1522–1523
		The Vendramin Family Oil on canvas, 206 x 301 cm London, National Gallery 1543–1547	

Czech Republic		*The Flaying of Marsyas* Oil on canvas, 212 x 207 cm Kromeríz Archbishop's Palace 1570–1576	

Russia		*The Penitent Magdalene* Oil on canvas, 118 x 97 cm St Petersburg, The State Hermitage Museum 1565	*Saint Sebastian* Oil on canvas, 210 x 115.5 cm St Petersburg, The State Hermitage Museum *c.* 1570

Spain		*The Andrians (Bacchanalia)* Oil on canvas, 175 x 193 cm Madrid, Museo Nacional del Prado 1523–1524	*Alfonso D'avalos* *Addressing his Troops* Oil on canvas, 223 x 165 cm Madrid, Museo Nacional del Prado 1540–1541
	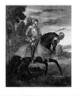	*Charles V on Horseback* Oil on canvas, 322 x 279 cm Madrid, Museo Nacional del Prado 1548	*Venus with an Organist* *and a Dog* Oil on canvas, 136 x 220 cm Madrid, Museo Nacional del Prado 1550–1551
	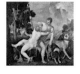	*Venus and Adonis* Oil on canvas, 136 x 220 cm Madrid, Museo Nacional del Prado 1553–1554	*Entombment* Oil on canvas, 130 x 168 cm Madrid, Museo Nacional del Prado 1559

Spain

Religion Succored by Spain
Oil on canvas, 168 x 168 cm
Madrid, Museo Nacional del
Prado
1572–1574

USA

*Portrait of Cardinal Pietro
Bembo*
Oil on canvas, 94.5 x 76.5 cm
Washington, National
Gallery of Art
1539

Ranuccio Farnese
Oil on canvas,
89.7 x 73.6 cm
Washington, National
Gallery of Art
1542

Doge Andrea Gritti
Oil on canvas,
133.6 x 103.2 cm
Washington, National
Gallery of Art
1545–1548

Venus with a Mirror
Oil on canvas,
124.5 x 104.1 cm
Washington, National
Gallery of Art
c. 1555

Writings

An excerpt from Giorgio Vasari's Lives of the Painters, Sculptors, and Architects.

TIZIANO DA CADORE, PAINTER

Tiziano was born at Cadore, a little township situated on the Piave and five miles distant from the pass of the Alps, in the year 1480, from the family of the Vecelli, one of the most noble in that place. At the age of ten, having a fine spirit and a lively intelligence, he was sent to Venice to the house of an uncle, and honoured citizen, who, perceiving the boy to be much inclined to painting, places him with Gian Bellini, an excellent painter very famous at that time, as has been related. Under his discipline, attending to design, he soon showed that ha was endowed by nature with all the gifts of intellect and judgment that are necessary for the art of painting; and since at that time Gian Bellini and the other painters of that country, from not being able to study ancient works, were much—nay, altogether—given to copying from the life whatever work they did, and that with a dry, crude, and laboured manner, Tiziano also for a time learned that method. But having come to about the year 1507, Giorgione da Castelfranco, not altogether liking that mode of working, began to give his pictures more softness and greater relief, with a beautiful manner; nevertheless he used to set himself before living and natural objects and counterfeit them as well as he was able with colours, and paint the broadly with tints crude or soft according as the life demanded, without doing any drawing, holding it as certain that to paint with colours only, without the study of drawing on paper, was the true and best method of working, and the true design. For he did not perceive that for him who wishes to distribute his compositions and accommodate his own inventions well, it is necessary that he should first put them down on paper in several different ways, in order to see how the whole goes together, for the reason that the idea is not able to see or imagine the inventions perfectly within herself, if she does not reveal and demonstrate her conception to the eyes of the body, that these may assist her to form a good judgment. Besides which, it is necessary to give much study to the nude, if you wish to comprehend it well, which you will never do, not is it possible, without having recourse to paper; and to keep always before you, while you paint, persons naked or draped, is no small restraint, whereas, when you have

formed your hand by drawing on paper, you then come little by little with greater ease to carry on your conceptions into execution, designing and painting together. And so, gaining practice in art, you make both manner and judgment perfect, doing away with the labour and effort wherewith those pictures were executed of which we have spoken above, not to mention that by drawing on paper, you come to fill the mind with beautiful conceptions, and learn to counterfeit all the objects of nature by memory, without having to keep them always before you or being obliged to conceal beneath the glamour of colouring the painful fruits of your ignorance of design, in the manner that was followed for several years by the Venetian painters, Giorgione, Palma, Pordenone, and others, who never saw Rome or any other works of absolute perfection.

Tiziano, then, having seen the method and manner of Giorgione, abandoned the manner of Gian Bellini, although he had been accustomed to it for a long time, and attached himself to that of Giorgione; coming in a short time to imitate his works so well, that his pictures were at times mistaken for works by Giorgione, as will be related below. Then, having grown in age, practice, and judgment, Tiziano executed many works in fresco, which cannot be enumerated in order, being dispersed over various places; let it suffice that they were such, that the opinion was formed by many experienced judges that he would become, as he afterwards did, a most excellent painter. At the time when he first began to follow the manner of Giorgione, not being more of eighteen years of age, he made the portrait of a gentleman of the Barberigo family, his friend, which was held to be very beautiful, the likeness of the flesh-colouring being true and natural, and all the hairs so well distinguished from one another, that they might have been counted, as also might the stitches in a doublet of silvered satin that he painted in that work. In short, it was held to be so well done, and with such diligence, that if Tiziano had not written his name on a dark ground, it would have been taken for the work of Giorgione.

Meanwhile Giorgione himself had executed the principal façade of the Fondaco de' Tedeschi, and by means of Barberigo there were allotted to Tiziano certain scenes on the same building, above the Merceria.

After which work he painted a large picture with figures of the size of life, which is now in the hall of M. Andrea Loredano, who dwells near S. Marcuola. In that picture is painted Our Lady going into Egypt, in the midst of a great forest and certain landscapes that are very well done, because Tiziano had given his attention for many months to such things, and had kept in his house for that purpose some Germans who were excellent painters of landscape and verdure. In the wood in that picture, likewise, he painted many animals, which he portrayed from the life; and they are truly natural, and almost alive. Next, in the house of M. Giovanni D'Anna, a Flemish gentleman and merchant, his gossip, he made his portrait, which has all the appearance of life, and also an "Ecce Homo" with many figures, which is held by Tiziano himself and by others to be a very beautiful work. The same master painted a picture of Our Lady with other figures the size of life, of men and children, all portrayed from the life and from persons of that house. Then in the year 1507, while the Emperor maximilian was making war on the Venetians, Tiziano, according to his own account, painted an Angel Raphael with Tobias and a dog in the Church of S. Marziliano, with a distant landscape, where, in a little wood, S. john the Baptist is praying on his knees to Heaven, whence comes a radiance that illumines him; and this work it is thought that he executed before he made a beginning with the façade of the Fondaco de' Tedeschi. Concerning which façade, many gentlemen, not knowing that Giorgione was not working there any more and that Tiziano was doing it, who had uncovered one part, meeting with Giorgione, congratulated him in friendly fashion, saying that he was acquitting himself better in the façade towards the Merceria than he had done in that which is over the Grand Canal. At which circumstance Giorgione felt such disdain, that until Tiziano had completely finished the work and it has become well known that the same had done that part, he would scarcely let himself be seen; and from that time onward he would never allow Tiziano to associate with him or be his friend.

In the year after, 1508, Tiziano published in wood-engraving the Triumph of Faith, with an infinity of figures; our first Parents, the Patriarchs, the Prophets, the Sibyls, the Innocents, the Martyrs, the Apostles,

179

and Jesus Christ borne in Triumph by the four Evangelists and the four Doctors, with the Holy Confessors behind. In that work Tiziano displayed Boldness, a beautiful manner, and the power to work with facility of hand; and I remember that Fra Sebastiano del Piombo, conversing of this, said to me that if Tiziano had been in Rome at that time, and had seen the works of Michelagnolo, those of Raffaello, and the ancient statues, and had studied design, he would have done things absolutely stupendous, considering the beautiful mastery that he had in colouring, and that he deserved to be celebrated as the finest and greatest imitator of Nature in the matter of colour in our times, and with the foundation of the grand method of design he might have equaled the Urbinate and Buonarroti. Afterwards, having gone to Vicenza, Tiziano painted the Judgment of Solomon in fresco, which was a beautiful work, under the little loggia where justice is administered I, n public audience. He then returned to Venice, and painted the façade of the Grimani. At Padua, in the Church of S. Antonio, he executed likewise in fresco some stories of the actions of that Saint, and for that of S. Spirito he painted a little altar-piece with a S. Mark seated in the midst of certain Saints, in whose faces are some portraits from life done in oils with the greatest diligence; which picture many have believed to be by the hand of Giorgione. Then, a scene having been left unfinished in the Hall of the Great Council through the death of Giovanni Bellini, wherein Frederick Barbarossa is kneeling at the door of the Church of S. Marco before Pope Alexander IV, who places his foot in Barabrossa's neck, Tiziano finished it, changing many things, and making there many portraits from life of his friends and others; for which he was rewarded by receiving from the Senate an office in the Fondaco de' Tedeschi, called the Senseria, which yields three hundred crowns a year. That office those Signori are accustomed to give to the most excellent painter of their city, on the condition that he shall be obliged from time to time to paint the portrait of their Prince or Doge, at his election, for the price of only eight crowns, which the Prince himself pays to him; which portrait is afterwards kept, in memory of him, in a public place in the Palace of S. Marco.

In the year 1514 Duke Alfonso of Ferrara had caused a little chamber to be decorated, and had commissioned Dosso, the painter of Ferrara, to execute in certain compartments stories of Æneas, Mars, and Venus, and in a grotto Vulcan with two smiths at the forge; and he desired that there should also be there pictures by the hand of Gian Bellini. Bellini painted on another wall a vat of red wine with some Bacchanals around it, and Satyrs, musicians, and other men and women, all drunk with wine, and near them a nude and very beautiful Silenus, riding on his ass, with figures about him that have the hands full of fruits and grapes; which work was in truth executed and coloured with great diligence, insomuch that it is one of the most beautiful pictures that Gian Bellini ever painted, although in the manner of the draperies there is a certain sharpness after the German manner (nothing, indeed, of any account), because he imitated a picture by the Fleming Albrecht Dürer, which had been brought in those days to Venice and placed in the Church of S. Bartolommeo, a rare work and full of the most beautiful figures painted in oils. On the vat Gian Bellini wrote these words: "JOANNES BELLINUS VENETUS, P. 1514"

That work he was not able to finish completely, because he was old, and Tiziano, as the most excellent of all the others, was sent for the end that he might finish it; wherefore, being desirous to acquire excellence and to make himself known, he executed with much diligence two scenes that were wanting in that little chamber. In the first is a river of red wine, about which are singers and musicians, both men and women, as it were drunk, and a naked woman who is sleeping, so beautiful that she might be alive, together with other figures; and on this picture Tiziano wrote his name. In the other, which is next to it and seen first on entering, he painted many little boys and Loves in various attitudes, which much please that lord, as also did the other picture; but the most beautiful of all is one of those boys who is making water into a river and is reflected in the water, while the others are around a pedestal that has the form of an altar, upon which is a statue of Venus with a sea-conch in the right hand, and Grace and Beauty about her, which are very lovely figures and executed with incredible diligence. On the door of a press, likewise, Tiziano painted an image of Christ

from the waist upwards, marvelous, nay, stupendous, to whom a base Hebrew is showing the coin of Cæsar; which image, and also other pictures in that chamber, our best craftsmen declare to be the finest and best executed that Tiziano has ever done, and indeed they are most rare. Wherefore he well deserved to be most liberally recompensed and rewarded by that lord, whom he portrayed excellently well with one arm resting on a piece of artillery; and he also made a portrait of Signora Laura, who afterwards became the wife of the Duke, which is a stupendous work. And, in truth, gifts have great potency with those who labour for the love of art, when they are uplifted by the liberality of Princes. At that time Tiziano formed a friendship with the divine Messer Lodovico Ariosto, and was recognized by him as a most excellent painter and celebrated in his Orlando Furioso: "...E Tizian che onora / Non men Cador, che quei Vinezia e Urbino."

Having then returned to Venice, Tiziano painted on a canvas in oils, for the father-in-law of Giovanni da Castel Bolognese, a naked shepherd and a country girl who is offering him some pipes, that he may play them, with a most beautiful landscape; which picture is now at Faenza, in the house of the said Giovanni. He then executed for the high-altar in the Church of the Friars Minors, called the Cà Grande, a picture of Our Lady ascending into heaven, and below her the twelve Apostles, who are gazing upon her as she ascends; but of this work, for its having been painted on cloth, and perhaps not well kept, there is little to be seen. For the Chapel of the Pesari family, in the same church, he painted in an altar-piece the Madonna with the Child in her arms, a S. Peter and a S. George, and about them the patrons of the work, kneeling and portrayed from life; among whom are the Bishop of Paphos and his brother, then newly returned from the victory which that Bishop won against the Turks. For the little Church of S. Niccolò, in the same convent, he painted in and altar-piece S. Nicholas, S. Francis, S. Catherine, and also a nude S. Sebastian, portrayed from life and without any artifice that can be seen to have been used to enhance the beauty of the limbs and trunk, there being nothing there but what he saw in the work of nature, insomuch that it all appears as if stamped from the

life, so fleshlike it is and natural; but for all that it is held to be beautiful, as is also very lovely the Madonna with the Child in her arms at whom all those figures are gazing. The subject of that picture was drawn on wood by Tiziano himself, and then engraved by others and printed. For the Church of S. Rocco, after the works described above, he painted a picture of Christ with the Cross on His shoulder, and about His neck a cord that is drawn by a Hebrew; and that figure, which many have believed to be by the hand of Giorgione, is now the object of the greatest devotion in Venice, and has received in alms more crowns than Tiziano and Giorgione ever gained in all their lives. Then he was invited to Rome by Bembo, whom he had already portrayed, and who was at that time Secretary to Pope Leo X, to the end that he might see Rome, Raffaello da Urbino, and others; but Tiziano delayed that visit so long from one day to another, that Leo died, and Raffaello in 1520, and after all he never went. For the Church of S. Maria Maggiore he painted a picture with S. John the Baptist in the Desert among some rocks, an Angel that appears as if alive, and a little piece of distant landscape with some trees upon the bank of a river, all full of grace.

He made portraits from life of the Prince Grimani and Loredano, which were held to be admirable; and not long afterwards of King Francis, when he departed from Italy in order to return to France. And in the year when Andrea Gritti was elected Doge, Tiziano painted his portrait, which was a very rare thing, in a picture wherein are Our Lady, S. Mark, and S. Andrew with the countenance of that Doge; which picture, a most marvelous work, is in the Sala del Collegio. He has also painted portraits, in addition to those of the Doges named above (being obliged, as has been related, to do it), of others who have been Doges in their time; Pietro Lando, Francesco Donato, Marcantonio Trevisano, and Venicro. But by the two Doges and brothers Paoli [Priuli] he has been excused recently, because of his great age, from that obligation. Before the sack of Rome there had gone to live in Venice Pietro Aretino, a most famous poet of our times, and he became very much the friend of Tiziano and Sansovino; which brought great honour and advantage to Tiziano, for the reason that the poet made him known wherev-

er his pen reached, and especially to Princes of importance, as will be told in the proper place.

Meanwhile, to return to Tiziano's works, he painter the altar-piece for the altar of S. Piero Martire in the Church of SS. Giovanni e Paolo, depicting therein that holy martyr larger than life, in a forest of very great trees, fallen to the ground and assailed by the fury of a soldier, who has wounded him so grievously in the head, that as he lies but half alive there is seen in his face the horror of death, while in another friar who runs forward in flight may be perceived the fear and terror of death. In the air are two nude Angels coming down from a flash of Heaven's lightning, which gives light to the landscape, which is most beautiful, and to the whole work besides, which is the most finished, the most celebrated, the greatest, and the best conceived and executed that Tiziano has as yet ever done in all his life. This work being seen by Gritti, who was always very much the friend of Tiziano, as also of Sansovino, he caused to be allotted to him a great scene of the rout of Chiaradadda, in the Hall of the Great Council. In it he painted a battle with soldiers in furious combat, while a terrible rain falls from Heaven; which work, wholly taken from life, is held to be the best of all the scenes that are in that Hall, and the most beautiful. And in the same Palace, at the foot of a staircase, he painted a Madonna in fresco. Having made not long afterwards for a gentleman of the Contarini family a picture of a very beautiful Christ, who is seated at table with Cleophas and Luke, it appeared to that gentleman that the work was worthy to be in a public space, as in truth it is. Wherefore having made a present of it, like a true lover of his country and of the commonwealth, to the Signoria, it was kept a long time in the apartments of the Doge; but at the present day it is in a public place, where it may be seen by everyone, in the Salotta d'Oro in from of the Hall of the Council of Ten, over the door. About the same time, also, he painted for the Scuola of S. Maria della Carità Our Lady ascending from the steps of the Temple, with heads of every kind portrayed from nature; and for the Scuola of S. Fantino, likewise, a little altar-piece of S. Jerome in Penitence, which was much extolled by the craftsmen, but was consumed by fire two years ago with the whole church.

It is said that in the year 1530, the Emperor Charles V being in Bologna, Tiziano was invited to that city by Cardinal Ippolito de' Medici, through the agency of Pietro Aretino. There he made a most beautiful portrait of his Majesty in full armour, which so pleased him, that he caused a thousand crowns to be given to Tiziano; but of these he was obliged afterwards to give the half to the sculptor Alfonso Lombardi, who had made a model to be reproduced in marble, as was related in his Life.

Having returned to Venice, Tiziano found that a number of gentlemen, who had taken Pordenone into their favour, praising much the works executed by him on the ceiling of the Sala de' Pregai and elsewhere, had caused a little altar-piece to be allotted to him in the Church of S. Giovanni Elemosinario, to the end that he might paint it in competition with Tiziano, who for the same place had painted a short time before the said S. Giovanni Elemosinario in the habit of a Bishop. But, for all the diligence that Pordenone devoted to that altar-piece, he was not able to equal or even by a great measure to approach the work of Tiziano. Next, Tiziano executed a most beautiful altar-picture of an Annunciation for the Church of S. Maria degli Angeli at Murano, but he who had caused it to be painted not being willing to spend five hundred crowns upon it, which Tiziano was asking, by the advice of Messer Pietro Aretino he sent it as a gift to the above-named Emperor Charles V, who, liking that work vastly, made him a present of two thousand crowns; and where that picture was to have been placed, there was set in its stead one by Pordenone. Nor had any long time passed when Charles V, returning to Bologna for a conference with Poe Clement, at the time when he came with his army from Hungary, desired to be portrayed again by Tiziano. Before departing from Bologna, Tiziano also painted a portrait of the above-named Cardinal Ippolito de' Medici in Hungarian dress, and in a smaller picture the same man in full armour; both which portraits are now in the guardaroba of Duke Cosimo. At that same time he executed a portrait of Alfonso Davalos, Marchese del Vasto, and one of the above-named Pietro Aretino, who then contrived that he should become the friend and servant of Federigo

Gonzaga, Duke of Mantua, with whom Tiziano went to his States and there painted a portrait of him, which is a living likeness, and then one of the Cardinal, his brother. These finished, he painted, for the adornment of a room among those of Giulio Romano, twelve figures from the waist upwards of the twelve Cæsars, very beautiful, beneath each of which the said Giulio afterwards painted a story from their lives.

In Cadore, his native place, Tiziano has painted an altar-picture wherein are Our Lady, S. Tiziano the Bishop, and a portrait of himself kneeling.

Extracts from A. Hume's Notices of the Life and Works of Titian

Being now in the prime of his life, he produced the fine picture of the Virgin's Ascension to Heaven, where the Padre Eterno, surrounded by Cherubs, is stretching out his arms to receive her. The Virgin, in a most powerful mass of light, is supported by a cloud, and accompanied by a very numerous host of Angels, in the most beautiful variety of attitudes; this group is, with infinite skill, connected with the assemblage of the Apostles below, who are in the act of reverence and adoration; among them, St. James is distinguished by a pilgrim's habit and a scallop shell. This picture was executed for the Chapel of the Convent of the Frari, at Venice; and as Titian there worked on it, he was frequently interrupted by the Friars, particularly by one Germano, who took it upon himself to criticise the large dimensions of the Apostles; Titian endeavoured in vain to set him right by explaining to him, that figures necessarily ought to be in proportion to the distance from which they are to be viewed, and that he would find when the picture was in its place, they would appear of their proper size. The Monks however were at length convinced of their ignorance, for the Emperor's Ambassador happening to see the picture, offered to purchase it for his master at a large price; this opened their eyes, and drew from them the confession that they were better acquainted with their breviaries, than with works of Art. Though this picture is full of grand effect, it is said that the

colouring is not so brilliant as his usually was; it formed part of the French plunder, but was restored in 1816, and is now in the Pinacotheca at Venice.

In the same Chapel of the Frari, was another picture by Titian, of the Conception, which represents the Madonna holding the Child in her arms, and leaning against a pedestal, by the side of which is St. Peter, with his hand on a book, and the keys at his feet, his eyes turned towards a figure kneeling, being the Vescovo di Baffo, whom St. George in armour is presenting to the Virgin upon his return, after the victory he obtained over the Turks; on the opposite side is St. Anthony of Padua, near whom, in attitudes of devotion, are the others of the Baffo family, for which family the picture was painted. This union of the military and ecclesiastical profession was common in early times.

OF TITIAN'S COLOURING AND MODE OF PAINTING
A knowledge of the colours used by Titian, and his mode of laying them on, has been the subject of anxious enquiry, as well as of abundant speculation; and it is to Boschini alone in his "Ricche miniere della Pittura Veneziana," that we are indebted for any knowledge of the subject. The particulars were communicated to him by the younger Palma, who, in his youth, was Titian's scholar.

Boschini proceeds to say, "Palma Giovane, told me, that he had had the good fortune to profit by Titian's precepts under his own eye, and that his practice in beginning his pictures was to lay on a mass or body of colour as a foundation or basis for the subject he intended to represent; after which, I have myself seen him lay on bold and masterly touches with a pencil [brush] full of colour, sometimes of pure red earth, which served as a middle tint; at other times with a pencil full of white, and the same pencil dipped in red, black, and yellow, with which he relieved the lights, and thus in a masterly manner he produced in four strokes, the promise of an admirable figure, and to intelligent persons it was a high gratification to see a mode so desirable to be adopted by the professors of the art. Titian having proceeded so far with a picture, turned it with its face to the wall, where he left it sometimes for months without looking at it; and when he felt disposed to work upon it again, he examined it with as

much severity, as if it had been his most capital enemy, in order to discover the defects, and then proceed to reform every part that did not accord with his feelings; and like an able surgeon, reducing the contours which happened to be too protuberant or overloaded with flesh, altering the drawing of the limbs, where the anatomy was incorrect, without sparing his labour, and thus obtaining the most beautiful symmetry, grounded on nature, and perfectioned by art. Titian went over each picture as the colours dried, laying on the flesh tints from time to time, with repeated touches; but it never was his practice to complete a figure at once, observing, that 'he who sings off hand, can never compose correct and faultless verses.' In order to bring the finishing touches to perfection, he blended them with a stroke of his finger, softening the edges of the lights with the half tints, and thus uniting them together, which gave force and relief to both. He sometimes put in with his finger a touch of dark in some angle, or a touch of a rich red tint, similar to a drop of blood,— giving by these means a surprising degree of animation to his figures. I was assured also by the younger Palma, that in finishing his pictures, Titian's practice was, to make more use of his fingers than of his pencil. Nothing could be more admirable than his children, and no one excelled him in his draperies, whether of silk, woolen, or linen; his weapons and armour were most faithfully represented by his pencil, and when he introduced architecture or stone work, they might be considered as admirable examples in that part of the art. His trees, plains, and mountains are true to nature; his animals are characterised with the greatest truth; but to his taste and feeling, in delineating the affections of the mind, no one can do adequate justice, so ready was he in expressing them, that if he intended to represent grief, he drew tears from the eye of the spectator; if joy, a correspondent sensation was raised; is valour, a martial spirit was excited; if modesty, every one felt conscious of its presence."

Boschini adds several curious particulars respecting the mode of painting adopted generally by the Venetian school at that period. He relates that, "The Masters made their sketches or designs, according to their genius and imagination, without availing themselves of living models, or the assistance of statues and bas-reliefs, but when the sketch was dry, the next step was to place nature before their eyes, and correcting its peculiarities by the assistance of the antique, but not confining themselves to copying closely either the one or the other; after which they laid on the flesh tints, using principally earthy colours; such as a small portion of cinnabar, minium, and lake, avoiding, as they would the plague, gambouge, smalt, blue-green, and yellow, together with all varnishes. After going over tha picture a second time, the relieved one colour from another by a low tint; then putting on a prominent touch of light, for example on a head or foot, of dry colour, with a spirited pencil, and glazing the shadows with asphaltum, observing to maintain a great breadth of demi-tint, introducing a considerable proportion of dark, but with few high lights."

In addition to the above quotations from Boschini, it is handed down among the Venetians, that Titian began to work by tinting a paper as his first sketch, and then transferring the same design to canvas, with little or no variation, and in finishing, with smart and spirited touches judiciously placed, concealed the repeated labour he had bestowed upon them. It is much to be regretted that Boschini makes no mention whatever of the medium or vehicle with which Titian mixed his colours, as it is probable the permanency and brilliancy, which many of his pictures maintain to this day, in great measure depended upon it; not but what the purity of the colours, being free from any extraneous substance, was another cause of their preservation; and it is said that several of the old painters paid the greatest attention to the manufacture of their colours, and some performed it with their own hands. Some persons have been inclined to think that the vehicle of the Venetian painters, was one, into which neither oil, water, or varnish entered; but considering the injury they receive from being wetted, or hanging in damp places, it may be thought that some were done partially with water colours, and also that moisture acting on gess grounds, might detach the colour; and it is in fact observable how easily the rich yellow of the Venetian draperies suffers by being wetted. More than one fine work of Titian had been ruined, and skinned to the bone, in attempting to investigate the vehicle he used,

and his mode of conducting his pictures; but his grand secret of all, appears to have consisted in the unremitting exercise of application, patience, and perseverance, joined to an enthusiastic attachment to his art; his custom was to employ considerable time in finishing his pictures, working on them repeatedly, till he brought them to perfection; and his maxim was, that whatever was done in a hurry, could not be well done, "*che canta al improviso, canta male.*"

Extracts from Jacob Burckhardt's The Cicerone.

In the central part of the school stands the gigantic figure of *Titian Vecelli* (1477–1573) who, in his life of nearly a century, either adopted, or himself created or gave the original idea to the younger generation that all Venice was capable of painting, There is no intellectual element in the school which he does not somewhere exemplify in perfection; he certainly also represents their limitations.

The divine quality in Titian lies in his power of feeling in things and men that harmony of existence which should be in them according to their natural gifts, or still lives in them, though troubled and unrecognised; what in real life is broken, scattered, limited, he represents as complete, happy, and free. This is the universal problem of art; but no one answers it so calmly, so simply, with such an experience of absolute conviction. In him this harmony was pre-established; to use a philosophical term, in a special sense he possessed a special mastery of all the mechanical artistic methods of the school; but several painters equal him in special instances. His grand power of conception, as we have just described it, is more essentially characteristic of him.

It is most easily seen in his portraits, in presence of which people certainly forget the question, how the master can, out of the scattered and hidden traits, have called into life such grand beings. But anyone who wishes to pursue this subject requires no further explanatory word. Out of the immense number of portraits which bear the name of Titian in the Italian galleries, we shall mention only the most excellent and certainly genuine; any judgment concerning the others may be left undecided.

There are in the P. Pitti, of the first rank and altogether worthy of the master, the three-quarter length of Ippolito Medici, in Hungarian costume, no. 201, and Philip II, a whole figure, no. 200; in the Uffizii, the Archbishop of Ragusa, of 1552 (Tribune); the Duke of Urbino, in armour, standing before some red plush drapery, and the formerly beautiful elderly Duchess in the arm-chair, no. 605 and 597. [In the Naples museum, the well-known half-length figure of Paul III sitting in an arm-chair; the same Pope with an attendant, a large unfinished picture of the master, excellent; farther, the most beautiful of all, the whole-length standing figure of Philip II, which may rival the master-piece in Madrid.] One may again and again cultivate one's eye on these pictures, and try to enter into the infinite mastery of Titian, which cannot be described satisfactorily in any words. Further, let us not allow criticism to deprive us of the less excellent and doubtful, or certainly ungenuine portraits of the master; there is a great deal to admire also in these, especially compared with modern painting, in the conception of the characters, the simple arrangement, the fundamental tone of the colour.

Now follow some pictures about which we shall always doubt how far they were painted as portraits, how far out of pure artistic impulse, and whether one has before one some particular beauty, or a problem of beauty grown into a picture. First of all, La Bella, in the Pitti: the dress (blue, violet, gold, white), apparently chosen by the painter, mysteriously harmonizing with the charming luxuriant character of the head; it is the same person as the famous Venus of the Uffizii, and also the Duchess there. Then the most noble female type which Titian has produced, La Bella, in the P. Sciarra at Rome (the dress white, blue, and red, undoutably by Titian, in spite of the blacker shadows in the flesh; below, on the left, the cipher [TΛMBEND]);[1] and the Flora[2] in the Uffizii with her left hand lifting up a damask drapery, with her right offering roses. However great may have been the beauty of the woman who gave the impulse to these two pictures, in any case Titian first placed her on the height which makes this head appear in a sense as the counterpart of the Venetian type

of the Head of Christ. (The so-called Schiava in the P. Barberini at Rome is only the work of and imitator.) Perhaps, also, the beautiful picture of three half-length figures, which in the P. Maufrin was formerly called Giorgione, is rather by Titian; a young noble, who is turning round to a lady, whose features recall the Flora, on the other side a boy with a feather in his cap. The costumes are those of about 1520. [... In the Palazzo Strozzi at Florence is found the figure of a fair-haired girl, still a child, with pearls round her neck, a heavy gold chain round her body, and a lap-dog, with the name of the master, of his middle period. Beautiful in execution, well preserved, and authenticated by the document of the payment.]

Titian has also in certain nude figures solved other problems of a lofty existence, and at the same time achieved a triumph in the pictorial representation again attained. In the Tribune of the Uffizii the two famous pictures, the one marked as Venus by the presence of Cupid, the other without any mythological indication, yet also Venus. The latter is certainly the earliest; the head has the features of the Bella in the P. Pitti.[3] Figures of this kind so often mislead modern, especially French painters. Why are these forms eternal, while the modern so rarely produce anything more than beautiful nude studies? Because the motive and the import, and the light and colours, and form arose and grew together in the mind of Titian. What is created in this manner is eternal. The delicious cast of the figures, the harmony of the flesh tints, with the golden hair and the white linen, and many other special beauties, here pass altogether into the harmony of the whole, nothing obtrudes itself separately. The other picture, similar in the lines of the principal figure, yet represents another type, and gives a different feeling, because of the red velvet drapery in place of the linen, as well as by its landscape background. A third recumbent figure, on a couch with a red canopy, in the Academy of S. Luca at Rome, is described by an inscription as Vanitas; a very beautiful work, but one which the author has not thoroughly examined. [Too stumpy for Titian.] In the Naples Museum a beautiful Danæ.

In single figures of religious subjects we hardly can expect in Titian the most dignified and suitable representation of the objects of which they bear the name. In general, Titian's characters, however grand and, in a certain sense, historical, they are in themselves, do not easily attain any historical significance; their individual life predominates.

In the well-known Magdalen, for instance, the repentant sinner is meant to be represented, but in the wonderful woman, whose hair streams like golden waves around her beautiful form, this is clearly only accessory. Principal copy, Pal. Pitti, another draped in a striped loose garment, also by Titian himself in the Naples Museum.... In John, the lonely preacher of repentance (Academy, Venice), the severe character of the subject is adhered to. A noble head, perhaps somewhat nervously suffering, with the expression of sorrow; with his right hand he beckons to the people (see the John of Raphael). The St. Jerome, of which Italy possesses at least one good example (Brera at Milan) is, pictorially, a lofty poetical work, energetic in form, beautiful in lines, a pleasant ensemble of the nude, the red drapery, the linen, with the steep hollow way as background, only the expression of the inspired ascetic is not sufficiently inward. In tingle heads of Christ, on the other hand, Titian has new-cast Bellini's ideal in a thoughtful, altogether intellectual, manner. The most beautiful is in Dresden (Cristo della Moneta): that in the Pal. Pitti, no. 228, is also a noble specimen. The large fresco picture of S. Christopher in the Doge's Palace (below, on the steps near the chapel) is one of those works of Titian's in which there seems to shine out a fresh impression received from Correggio.

After what has been said, it can no longer be doubted which among the large church pictures will produce the purest and most complete impression; they are the calm existence pictures; chiefly Madonnas, with Saints and Donators. Thus where one tone, one feeling, must fill the whole, where the special historical intention is in the back-ground, Titian is incomparably grand. The earliest of these pictures, St. Mark enthroned between four Saints, in the antechamber of the Sacristy of the Salute, is a marvel of fullness and nobleness in the characters, in tone golden and full of light. One special Santa conversazione also is the grand late picture of the Vatican gallery: six saints, some of them wearing a moderated ecstatic expression, move freely before a niche in ruins, above which the

Madonna appears in the clouds: two angels hasten to bring crowns to the child, which it throws down in a happy playfulness; farther above one sees the beginning of a glory of rays (of which the semi-circular termination with the dove of the Holy Ghost is still visible, but must be bent round to the back). Lastly, the most important and most beautiful of all presentation pictures, by means of which Titian fixed a true conception of subjects of this kind for all future time, according to pictorial laws of harmony in grouping and colour, and free aërial perspective. This is the picture in the Frari on one of the first altars to the left; several saints introduce the members of the Pesaro family kneeling below, to the Madonna enthroned on an altar. A work of quite unfathomable beauty, which the beholder will perhaps agree with me in feeling more personally fond of than any of Titian's pictures....

Once Titian seems to have followed Correggio very closely. The three pictures on the ceiling in the Sacristy of the Salute, The Death of Abel, the Sacrifice of Abraham, and the dead Goliath, are, as I believe, the earliest Venetian pictures taken to give a view from below, "di sotto in sù." In reality, this mode of representation was not according to the nature of the Venetian painters, who wished to represent real existence, and not to astonish by an illusive appearance of imaginary localities. Besides this, they are earthly not heavenly events, and hence the view from below is only of that half kind which henceforth prevails in hundreds of Venetian ceiling paintings. The forms are contracted by it in an unbeautiful manner (the kneeling Isaac!), but the painting is still excellent.

Mythological works must, in any style that is realistic rather than ideal, be more inharmonious in proportion as their subject is heroic, and more harmonious, according as they approach the Idyllic and Pastoral. Titian seems to have felt this more clearly than most of his contemporaries. His chief subjects are Bacchanalia, in which beautiful and even luxurious existence comes to its highest point. The originals are in London and Madrid. There is an episode from "Bacchus and Ariadne" (reputed to be by Titian himself, but more probably by a non-Venetian of the seventeenth centu-

ry), in the Pal. Pitti. In a famous picture in the spirit of Correggio's Leda, namely, the representation of the Guilt of Calisto, there are several copies by his own hand scattered throughout Europe. The one in the Academy of S. Luca at Rome, of which about a third is wanting, appeared to me (on cursory examination) to be a beautiful original work. Another well-known composition is now only represented in Italy, by copies, since the sale of the Camuccini gallery, which possessed a beautiful original sketch: Venus tries to detain Adonis, who is rushing to the chase; a beautiful conception as to lines, form, and colour, and also a proper episode of idyllic sylvan life. Also in the Pal. Borghese: the late half-length picture of the arming of Cupid: wonderfully naïve and beautiful in colour. It is not mythological, but quite poetical, that an amorino tries by fair words to gain permission to fly away, while the eyes of the other are bound.

Lastly, Titian has painted two pictures without any mythological conception, simple allegories, if you will, but of that rare kind in which the allegorical sense which can be expressed is quite lost in comparison with an inexpressible poetry. Of one, the Three Ages of Man, Sassoferrato's beautiful but less powerful copy is found in the Pal. Borghese at Rome. (A shepherd and shepherdess on a sylvan meadow, on one side children, in the distance an old man.) The other, in the Borghese Palace at Rome: " Amor sacro ed Amor profano," that is, Love and Prudery [the old Italian title, probably a wrong one. Ridolfi (1646) calls it, "Due donne vicino ad un fonte, entro a cui si specchia un fanciullo"], a subject which had already been treated by Perugino. The meaning is exemplified in all possible ways: the complete covering of one figure,[3] even with gloves; the plucked rose; on the sarcophagus of the stream, the bas-relief of a Cupid wakened out of sleep by Genii with blows from their whips; the rabbits; the pair of lovers in the distance. Both pictures, especially the former, exercise the dreamy charm over one, which one can only describe by comparison, and which perhaps is only desecrated by words.

[1] The initial letters of some verse.
[2] The Duchess of Urbino is of the same type.
[3] She reminds us of the Flora and the Bella in the Pal. Sciarra.

An excerpt from Sir Joshua Reynolds' Discourses.

The conduct of Titian in the picture of Bacchus and Ariadne has been much celebrated, and justly, for the harmony of colouring. To Ariadne is given (say the critics) a red scarf, to relieve the figure from the sea, which is behind her. It is not for that reason alone, but for another of much greater consequence; for the sake of the general harmony and effect of the picture. The figure of Ariadne is separated from the great group, and is dressed in blue, which, added to the colour of the sea, makes that quantity of cold colour which Titian thought necessary for the support and brilliancy of the great group; which group is composed, with very little exception, entirely of mellow colours. But as the picture in this case would be divided into two distinct parts, one half cold, and the other warm, it was necessary to carry some of the mellow colours of the great group into the cold part of the picture, and a part of the cold into the great group; accordingly, Titian gave Ariadne a red scarf, and to one of the Bacchante a little blue drapery.

The light of the picture, as I observed, ought to be of a warm colour; for though white may be used for the principal light, as was the practice of many of the Dutch and Flemish painters, yet it is better to suppose *that white* illumined by the yellow rays of the setting sun, as was the manner of Titian. The superiority of which manner is never more striking than when in a collection of pictures we chance to see a portrait of Titian's hanging by the side of a Flemish picture (even though that should be of the hand of Vandyke), which, however admirable in other respects, becomes cold and grey in the comparison.

Extracts from Johann Wolfgang von Goethe's Travels in Italy

VERONA

The artists have racked their invention in order to get something striking out of such wretched subjects. And yet, stimulated by the urgency of the case, genius has produced some beautiful things. An artist, who had to paint S. Ursula with the eleven thousand virgins, has got over the difficulty cleverly enough. The saint stands in the foreground, as if she had conquered the country. She is very noble, like an Amazionian virgin, and without any enticing charms; on the other hand, her troop is shown descending from the ships, and moving in procession as a diminishing distance. The Assumption of the Virgin, by Titian, in the dome, has become much blackened, and it is a thought worth of praise that, at the moment of her apotheosis, she looks not toward heaven, but toward her friends below.

PADUA

In the consistory of a fraternity dedicated to S. Anthony, there are some pictures of an early date, which remind one of old German paintings, and also some by Titian, in which may be remarked the great progress which no one has made on the other side of the Alps.

VENICE

My old gift of seeing the world with the eyes of that artist, whose pictures have most recently made an impression on me, has occasioned me some peculiar reflections. It is evident that the eye forms itself by the objects which, from youth up, it is accustomed to look upon, and so the Venetian artist must see all things in a clearer and brighter light than other men. We, whose eye when out of doors, falls on a dingy soil, which, when not muddy, is dusty,—and which, always colourless, gives a sombre hue to the reflected rays, or at home spend out lives in close, narrow rooms, can never attain to such a cheerful view of nature.

As I floated down the lagunes in the full sunshine, and observed how the figures of the gondoliers in their motley costume, and as they rowed, lightly moving above the sides of the gondola, stood out from the bright green surface and against the blue sky, I caught the best and freshest type possible of the Venetian school. The sunshine brought out the local colours with dazzling brilliancy, and the shades even were so luminous, that, comparatively, they in their turn might serve as lights. And the same may be said of the reflection from the sea-green water. All was painted "chiaro nell chiaro," so that the foamy

waves and lightning flashes were necessary to give it a grand finish.

Titian and Paul have this brilliancy in the highest degree, and whenever we do not find it in any of their works, the piece is either damaged or has been touched up.

From Athens, too, in all probability, came two bas-reliefs which have been introduced in the church of St. Justina, the conqueress of the Turks. Unfortunately they are in some degree hidden by the church seats. The sacristan called my attention to them on account of the tradition that Titian modelled from them the beautiful angel in his picture of the martyrdom of St. Peter. The relievos represent genii who are decking themselves out with the attributes of the gods,—so beautiful in truth, as to transcend all idea or conception.

*F*rom Fragments of a Traveler's Journal.

Altogether Titian has held quite close by the old style, and only ennobled it by greater warmth and art.

Titian has painted another thaumaturgic picture; Tintoretto can scarcely be said to have done so, though smaller painters have attained to this happiness.

Paul Veronese and Titian worked mostly with glazes. The first colours laid on were light, which they covered with darker transparent tints. For this reason their pictures grow lighter rather than darker with age, although the Titians have also suffered from the much oil superimposed on them.

I accidentally made the acquaintance of this academy. Once, when I was contemplating with great attention Titian's charming picture, "The Murder of Peter Martyr," in the church above mentioned [the church of Saints John and Paul], a monk asked me whether I would not like to see the gentlemen above referred to [academy members], whose business he explained to me. I was received in a friendly way; and, when they noticed the special attention I directed to their labours, an attention to which I gave expression with a German naturalness, they became kindly affected towards me, as I may venture to say. I accordingly returned fre-

quently, always testifying my reverence for the unique Titian.

Had I written down at home, on each occasion, what I saw and heard, it would now stand me in good stead. I will here, however, from memory, describe one peculiar proceeding in one of the most remarkable cases.

Titian and his followers painted, among other materials, on figured damask, of linen fabric and unbleached, as it came from the weaver, without any priming. The whole thereby received a certain double light which is peculiar to damask. The particular parts thus acquired an indescribable life, the colour never remaining the same to the spectator, but passing by a peculiar movement from bright to dark, and vice versa, losing everything of a material appearance. I remember yet, quite distinctly, a *Christ* by Titian, where the feet stood quite close before your eyes, in which a pretty rough square pattern of damask was to be detected through the flesh colour. On removing, however, to some distance, a living epiderm, with all kinds of mobile indentations, appeared to play before the eye.

*A*n excerpt from Gerhard Richter's The Daily Practice of Painting: Writings 1962–1993. *From the* Interview with Jonas Storsve, 1991

In 1979 you painted a cycle of works after Titian's Annunciation (in the Scuola Grande di San Rocco). Why did you choose that picture in particular?

Simply because I liked it so much. I saw it in Venice and I thought: I'd like to have that for myself. To start with, I only meant to make a copy, so that I could have a beautiful painting at home and with it a piece of that period, all that potential beauty and sublimity. I really don't know what the period was like: maybe it was ghastly. But the theme is very beautiful. This woman to whom something is being announced: a beautiful truth, and no doubt well painted. But then my copy went wrong, and the pictures that finally emerged went to show that it just can't be done any more, not even by way of a copy. All I could do was break the whole thing down and show that it's no longer possible.

Concise Bibliography

Berenson, Bernard. *The Northern Italian Painters of the Renaissance.* London: Chapman & Hall, 1897.

Burckhardt, Jacob. *The Cicerone.* London: John Murray, 1873.

Crowe, J. A. and G.B. Cavalcaselle. *Titian: His Life and Times.* London: John Murray, 1877.

Fischel, Oskar. *The Work of Titian.* New York: Brentano's, 1921.

Hume, A. *Notices of the Life and Works of Titian.* London: J. Rodwell, 1829.

Martineau, J. and C. Hope. *The Genius of Venice 1500–1600.* London, 1983.

Pedrocco, Filippo. *Titian.* New York: Rizzoli International Publications, 2001.

Phillips, C. *The Earlier Work of Titian.* London, 1897.

Pignatti, T. *The Golden Age of Venetian Painting.* Los Angeles, 1979.

Rosand, D. *Titian.* New York, 1978.

Rose, George B. *The World's Leading Painters: Leonardo da Vinci, Raphael, Titian, Rubens, Velasquez, and Rembrandt.* New York: Henry Holt & Company, 1912.

Vasari, Giorgio. *Lives of the Painters, Sculptors, and Architects (2 Volumes).* London: David Campbell Publishers, 1996.

Wethey, E. H. *The Complete Painting of Titian.* London, 1975.